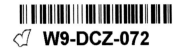
Public and Private: American Prints Today

Public and Private: American Prints Today

The 24th National Print Exhibition

Barry Walker

The Brooklyn Museum

Published for the exhibition
Public and Private: American Prints Today
The 24th National Print Exhibition

The Brooklyn Museum, New York
February 7–May 5, 1986

Flint Institute of Arts, Flint, Michigan
July 28–September 7, 1986

Rhode Island School of Design, Providence, Rhode Island
September 29–November 9, 1986

Museum of Art, Carnegie Institute, Pittsburgh, Pennsylvania
December 1, 1986–January 11, 1987

Walker Art Center, Minneapolis, Minnesota
February 1–March 22, 1987

This exhibition was made possible, in part, by a grant
from the National Endowment for the Arts, a federal agency.

Front cover:
David Hockney
Red Celia 1985
Lithograph; edition of 82
Sheet: 76.3 x 54.6 cm (30 x 21½ in.)
Lent by Tyler Graphics, Ltd., New York
Photo: ©Steven Sloman
Cat. no. 47

Back cover:
Roberto Juarez
Arrowroot 1985
Woodcut; edition of 40
Image: 115.5 x 91.4 cm (45½ x 36 in.)
Sheet: 124.5 x 96.5 cm (49 x 38 in.)
Lent by Chip Elwell, New York
Cat. no. 51

Frontispiece:
Nathan Oliverira
Kestrel Series #10 1985
Woodcut, hand-colored with pastel and
 graphite pencil; edition unique
Image: 101.6 x 75 cm (40 x 29½ in.)
Sheet: 122 x 75 cm (48 x 29½ in.)
*Lent by Experimental Workshop,
 San Francisco*
Photo: Diana Crane
Cat. no. 67

Library of Congress Cataloging-in-Publication Data

National Print Exhibition (24th : 1986–1987 :
 Brooklyn Museum, etc.)
 Public and private.

 Published for the exhibition held at the
Brooklyn Museum, New York, Feb. 7–May 5, 1986.
 Includes indexes.
 1. Prints, American—Exhibitions. 2. Prints—
20th century—United States—Exhibitions. I. Walker,
Barry, 1945– . II. Brooklyn Museum. III. Title.
NE508.N3 1986 769.973'074'014723 86-2596
ISBN 0-87273-104-9

Designed and published by The Brooklyn Museum,
200 Eastern Parkway, Brooklyn, New York 11238.
Typeset in Helvetica and printed in the U.S.A. by
Thorner-Sidney Press, Inc., Buffalo, New York.

©1986 The Brooklyn Museum

Contents

Jasper Johns
Ventriloquist 1985
Lithograph; edition of 67
Image and sheet: 106.8 x 71.1 cm (42 x 28 in.)
Collection: The Museum of Fine Arts, Houston. Museum purchase with funds provided by
 Mr. and Mrs. Bryan Trammel, Jr. Cat. no. 50 Photo: A. Mewbourn

Foreword

The National Print Exhibition, organized at the Museum since 1947, provides an important forum for contemporary currents in American printmaking. The nature of the exhibition is determined by what art American artists have produced in the field of printmaking in the period focused on and, of course, by the organizer's viewpoint.

For the current National Print Exhibition, our twenty-fourth, Barry Walker, Associate Curator of Prints and Drawings, has organized a survey of American printmaking during the last three years and has taken as his particular goal the way we look at prints. The title of the exhibition, *Public and Private: American Prints Today,* implies both the nature of the prints themselves and the perception of them. To encourage the private experience of viewing prints, duplicate sets of several portfolios and artists' books will be provided during the exhibition: one on the wall or in a case, while a second will be available by request for hand-held viewing.

In addition to thanking the many generous lenders, we especially wish to thank those publishers and dealers who have agreed to lend the duplicate sets for private perusal. Their sensitivity to the concept of the exhibition and their willingness to participate in an innovative way of showing prints is to be applauded. Our special gratitude therefore goes to Mark Baron, Peter Blum, Kathan Brown, Christopher Cordes, Margo Dolan, Joe Fawbush, Anthony Kirk, Ben Schiff, and Diane Villani.

Mr. Walker also received special assistance from Hiram Butler, Barbara Delano, Chip Elwell, Ceil Friedman, Bill Goldston, Allison Greene, Michael Hart, Kerry Kahn, Eileen Kapler, Greg Kucera, Carol Larson, Susan Lorence, Karen McCready, Arthur Roger, and Betsy Senior. Thanks is also due Bill Carroll, Assistant in the Department of Prints and Drawings, for organization of the exhibition, Peter Muscato, Conservation Assistant, for matting, and Christopher Rayburn, Museum Technician, for framing. We wish most heartily to thank all artists and lenders without whose support this exhibition could never have taken place.

This exhibition was made possible in part through a grant from the National Endowment for the Arts in Washington, D.C., a federal agency.

Robert T. Buck
Director
The Brooklyn Museum

Julian Schnabel
Mother 1985
Etching and aquatint on lithographed map; edition of 36
Overall size: 180.4 x 122 cm (71 x 48 in.)
Lent by Pace Editions, Inc., New York Cat. no. 83

Public and Private: American Prints Today

Barry Walker

When The Brooklyn Museum's National Print Exhibition debuted in 1947, everyone knew what a print was. A print was small in scale. It was usually black and white. It was inexpensive. It was generally made by an artist whose primary, if not sole, medium was printmaking. Its market was limited to a small circle of collectors whose passion was works on paper. The artist usually editioned his/her own work, although on occasion one of the very small band of professional printers performed this service. Prints were an oddity, occupying an ill-defined middle ground somewhere between high art and craft.

The few people who looked at prints at that time valued above all else their intimacy. Although some prints might be hung as decoration, the real connoisseur kept them in boxes or albums, from which they could be removed and examined in a contemplative moment. Held in the hand, often inspected with the aid of a loupe or a magnifying glass, prints were something to be cherished by one specialist at a time. Viewing prints was an intensely private experience, requiring an active participation on the part of the viewer. Looking at prints in this way was like reading poetry, in that full appreciation required the expenditure of effort, with the study of nuances of line and range of tonalities akin to attention to meter and structure.

Print collecting and connoisseurship were, at that time, a rather donnish activity. The typical collector was educated, affluent enough to buy art that was not intended for display, and with enough leisure time to devote considerable amounts of it to his/her avocation. Although printmaking is considered the most democratic of fine arts media for its capacity to produce multiple originals, the great collections were not shown publicly but maintained like a private library. Whereas paintings were acquired to be displayed and were thus, even in private collections, public to a degree, the aim of print collecting was not public display but private delectation.

In the 1950s, a small revolution in the way prints were produced, together with a broadened educational basis and a wider public awareness of art in general, led to a different type of print and a new kind of collector. The revolution in printmaking was in terms of size and color. As universities throughout the country opened printmaking facilities, larger presses could be acquired and printmaking students provided a new labor force for the editioning of printed images. The color print became the norm rather than the exception, and the larger press bed led to a radical increase in the scale of the print.

Concurrent with the expansion in scale and the addition of color in printmaking, the G.I. bill and the postwar boom economy brought about a generation more highly educated than any that had preceded it. This generation began to perceive art as for all, rather than for just the elite. An appreciation of art almost invariably leads to a desire to own it; and, as prints are the most affordable form of original art, print collecting became an avocation of the middle class.

The crucial difference between the new and the old generations of print collectors was that the new generation of collectors bought contemporary prints to display them on the wall. Whereas previous generations of print collectors were true amateurs who collected in depth, these neophytes collected, at least in part, for decoration. They bought prints because they were at once original and affordable. The attitude became, if it can't be shown, why have it. Rather than collecting prints for an appreciation of the qualities peculiar to the medium, prints began to be collected as substitutes for paintings.

When prints moved from the solander box to the wall, the perception of prints underwent a metamorphosis. Seeing a print no longer required a decision to get out a box to examine its contents one by one, for the new print was there, right on the wall. The decision therefore became simply to look at it or not to look at it. The print was constantly in one's sight, and, although one could still have an intense emotional and intellectual experience while looking at it, one could just as easily disregard it.

When prints became a public medium by going on the wall, the nature of the support presented different problems for viewing and display than that of a painting. Whereas a work on canvas did not require special protection, a work on paper is subject to drying, fading, and discoloration. Since prints must be glazed for protection, a barrier—albeit transparent—came between the viewer and the work of art. Looking at a print on a wall through glass is a very different experience from viewing it held in the hand without glazing. The former is a relatively impersonal experience, the latter far more active and personal.

Throughout the 1950s, printmakers tended to be specialists. Few notable painters or sculptors made prints. So, although prints began to emulate paintings in terms of color and scale, they retained many of the qualities traditional to printmaking. The images were essentially graphic; they had margins; and craftsmanship was important. Such processes as offset litho-

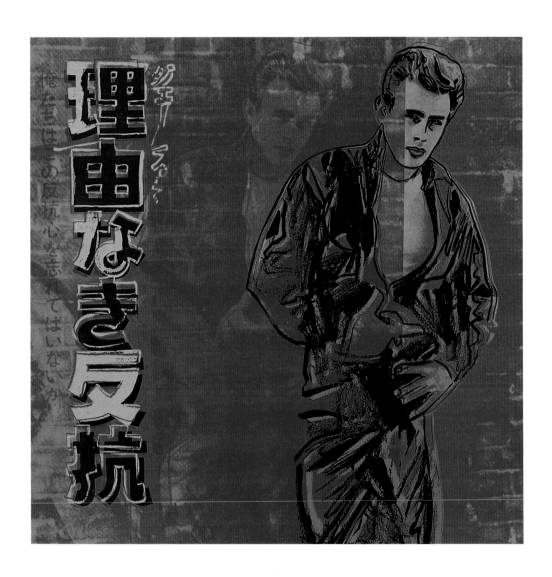

Andy Warhol
"Rebel Without a Cause" (James Dean)
 (from the portfolio *Ads*) 1985
Screenprint; edition of 190
Image and sheet: 96.5 x 96.5 cm (38 x 38 in.)
Lent by Ronald Feldman Gallery, New York Cat. no. 98
Photo: D. James Dee

graphy or photogravure were taboo. To qualify as an original print the artist had to work directly on the plate, stone, woodblock, or screen and either do his/her own printing or supervise the printing — the definition established by the Print Council of America in 1961.

The great revolution in American printmaking came in the late 1950s and throughout the 1960s with the establishment of the printmaking workshops and the development of a pool of master printers. The act of printmaking evolved from an essentially private experience in which the artist created and printed the image him/herself to a collaborative medium in which the artist created the image but it was the responsibility of the printers to produce an unvarying edition that fulfilled the artist's conception. Printmaking became a team effort in which the contribution of the master printer was vital to the success of the print.

With little or no experience in printmaking, most of the painters and sculptors who began making prints at this time came to the medium with no preconceptions. They presented problems for which the master printers had to develop new and innovative solutions. The prints of these artists looked, and indeed were, different from those of their predecessors. Most approached the medium with a painterly rather than a graphic sensibility. If a technique such as offset lighography, hitherto considered ineligible to meet the definition of originality, would further the realization of the image envisioned by the artist, why not use it? The image became paramount and the propriety of the technique used to achieve it a matter of indifference.

Since the inception of the workshops, the scale of American prints has increased radically. As scale has been a major concern of postwar painting, that painters should bring the same concern to their printed images was inevitable. With painters making prints, prints began to resemble paintings in terms of presence and authority.

During this period, the bleed image, printed to the sheet edge, was developed. As Whistler had believed before them, the new painter/printmakers reasoned that if a painting had no border, why should a print? A margin often calls attention to the fact that the image is transferred from another matrix onto the sheet, setting off the image area in a somewhat decorous and self-effacing way. Without borders, the viewer would concentrate on the image only, without being distracted by the physical properties of the support.

Throughout the 1960s and to this day, the products of American print workshops have largely been wall prints. A generation of print enthusiasts who have never actually held a print in their hands naturally look at prints in a way very different from that of previous generations of connoisseurs. With a large-scale print, one must put physical distance between oneself and the work in order to see the full composition. Close viewing elucidates details, but walking up to and away from a print on a wall is an experience of an entirely different quality from that of bringing a print closer to or further from the eye with one's hands. Both are forms of active viewing but with a vast qualitative difference.

Larry Thomas
Nagheezi Series #3 1985
Monotype over graphite drawing; edition unique
Image: 40.6 x 77.4 cm (16 x 30½ in.)
Sheet: 56.5 x 92.6 cm (22¼ x 36½ in.)
Lent by Experimental Workshop, California Cat. no. 95
Photo: Diana Crane

Throughout the 1970s, the thrust of mainstream American printmaking was to the perfectly uniform edition. Particularly during the perids of Op and Pop art, the desired aesthetic stressed mechanical perfection, the "cool" print that seemed almost untouched by human hands. The return to expressionism heralded a return to the more personal, the autographic mark, both in painting and in printmaking.

By 1980, a reaction in sensibilities had begun to set in against the machinelike perfection of the prints of the 1970s. The most notable manifestation of the new aesthetic in printmaking was the sudden popularity of the monotype. Only in a climate of high literacy of printmaking could the monotype flourish, for it is a unique image that employs properties of printmaking for strictly aesthetic purposes rather than for the possibility of making multiple originals. Most artists cite the same reason for making a monotype rather than a unique work created directly on the ultimate support; through the transfer process, a unique blending of the inks occurs which is unobtainable through direct work, and the inks have a different relationship with the paper than could be achieved by direct application.

The monotype is, in a sense, a more private form of printmaking than the editioned print in that it does not necessarily require a collaborator and, being unique, can only be in one collection. However, the large-scale monotypes and monoprints produced in workshops, such as Charles Arnoldi's *Rahway* (cat. no. 5) or Beverly Pepper's *Medieval Axe* (cat. no. 72), further blur the distinctions between painting and printmaking. Such works have an authority and presence similar to that of a painting and must be viewed on those terms.

Charles Arnoldi
Rahway 1985
Monoprint (wood relief monotype); edition unique
Image and sheet: 228.4 x 188 cm (90 x 74 in.)
Lent by New City Editions, California Cat. no. 5

Michael David
Untitled #8 1985
Monoprint, hand-colored with oil paint; edition unique
Image and sheet: 30.5 x 40.6 cm (12 x 16 in.)
Lent by Experimental Workshop, California Cat. no. 18
Photo: Diana Crane

The phenomenon of monoprints or editions variés and hand-colored prints, along with the gradual acceptance of photomechanical means of re-production, would make a precise definition such as that published by the Print Council of America in 1961 almost an impossibility today. Certainly a monoprint with hand-painting in oils, such as Michael David's *Untitled #8* (cat. no. 18), would never have been classified as a print twenty years ago and even today could be classified, with equal justification, as a print with hand-coloring or a painting on paper over printing.

Besides an aesthetic appreciation of the qualities peculiar to the mono-type, the growing popularity of the medium has a more mundane, economic basis, especially for emerging artists. When an artist is still developing a market for work in his/her primary medium, it makes little sense to print an edition for which there is essentially no distribution. With cost of print-workshop production reaching staggering heights, a publisher is unlikely to commission an edition from an artist without a proven record of sales. The young painter or sculptor who wants to make a print must therefore pay a

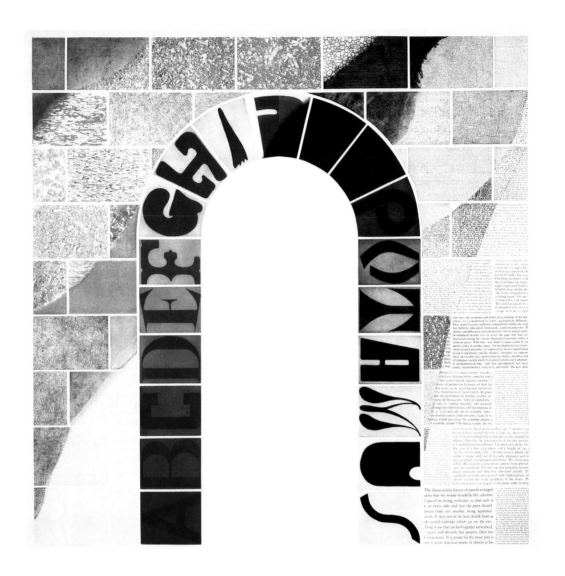

Vito Acconci
Building-Blocks for a Doorway 1983–85
Photo etching, hard-ground etching, soft-ground etching, and aquatint; edition of 8
Overall size: 238.4 x 240 cm (93⅞ x 94½ in.)
Lent by Carpenter + Hochman, New York Cat. no. 2
Photo: George Holzer

contract shop for press time and for the services of a master printer. While the cost of printing an edition would be prohibitive, one or more monotypes could be made in a day's session, thus enabling the artist the opportunity to work in a collaborative situation and produce work that could be priced compatibly with his/her other unique work.

In a way, some of the major publisher/printers have succeeded almost too well in creating the wall print that has the presence of the painting. Often requiring papers specially made for the project, the services of several master printers who are specialists in different fields of printmaking, and months of a workshop's time to realize an edition, such prints are no longer affordable to the average collector. When contemporary prints are released with prices of five figures, even museums have difficulty collecting representatively. A frequent complaint among curators active in the acquisition of contemporary prints is that storage is becoming almost impossible. Prints too large to fit in solander boxes or even in specially constructed drawers are routinely published. Because of their size and delicacy, such prints must be kept framed, a storage problem that few print departments can adequately meet.

The major trend persists, however, that many important, exciting, and innovative prints are published in large format. Vito Acconci's *Building-Blocks for a Doorway* (cat. no. 2), which is almost 8 feet by 8 feet, is the ultimate to date in the public print. One of Acconci's major concerns in his sculpture and video pieces is the interaction of people with three-dimensional objects in a public setting. One cannot view *Building-Blocks for a Doorway* without considering the possibility of passing through it, of having at least an imagined physical reaction with it. An arch signifies passage into a new space and, by extension, a metaphysical transposition. By making a print so big that the viewer could even conceive of walking through it, Acconci has gone beyond wedding printmaking to sculpture—he has wed printmaking to architecture, the most public of the plastic arts. Installation of *Building-Blocks for a Doorway* should ideally be around a doorframe, making it, in all probability, the first site-specific print.

Robert Rauschenberg's prints from his *Sling-Shots Lit* series are also public prints with architectonic elements. The wood lightbox superstructure is a window frame. Unlike Acconci, Rauschenberg does not invite the viewer to pass through the aperture but allows him/her to consider the selectivity of perception by raising or lowering two "shades" of clear mylar printed with diverse imagery. The back sheet is stationary, printed on sailcloth. The extent to which each shade is lowered defines the complexity of layered imagery.

Although *Building-Blocks for a Doorway* and *Sling-Shots Lit* are extremes in viewer-participation prints, other contemporary prints invite the viewer to partake in composing the ultimate image. In Eric Fischl's *Year of the Drowned Dog* (cat. no. 30), the three background sheets form a beach panorama. There are three smaller sheets that can be added as overlays to the central panel at the viewer's discretion, each additional sheet adding to the complexity of the composition. Although large overall, *Year of the*

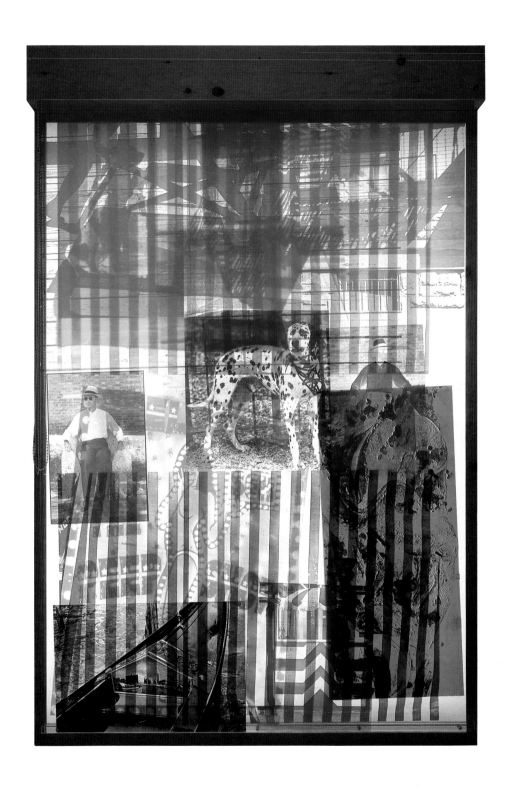

Robert Rauschenberg
Sling-Shots Lit #8 1984
Wood lightbox assemblage with lithography and screenprinting on mylar and sailcloth; edition of 25
Total assemblage: 214.6 x 137.2 x 33 cm (84½ x 54 x 13 in.)
Lent by Gemini G.E.L., California and New York Cat. no. 76

Drowned Dog incorporates certain aspects of earlier printmaking in that by manipulating the three small sheets by hand, the viewer has a private, participatory relationship with the print.

Although all three prints just discussed are essentially public or wall prints, the elements of viewer participation indicate that a reaction against the print as a substitute for painting is beginning to set in. The battle for acceptance of the artist's print as a medium that can hold its own with painting and sculpture has, for all intents and purposes, been won. A renewal of interest in the small-format print, less complex than the normal workshop product, is beginning to become apparent. Artists' books and small-format portfolios—by definition to be held in the hand—are beginning to enjoy a new popularity. The print meant to be viewed as a private, one-on-one experience between spectator and object is beginning to resurface after more than three decades of relative obscurity.

The return to the more intimate print does not by any means represent a complete rejection of the wall print. Many artists work in both scales. After making a series of extremely large prints at Tyler Graphics, Ltd. that are dazzling in their complexity and achievement, Steve Sorman returned to his Minnesota studio to print *Blue* (cat. no. 91), a portfolio of nine prints that, relative to his work at Tyler, is direct and intimate. Like many other artists, Sorman appreciates the qualities peculiar to both the private and the public modes of printmaking.

Crown Point Press established a program in 1982 of sending artists to Kyoto to work with Japanese master craftsmen in the traditional *ukiyo-e* style of woodblock printing. Although Judy Pfaff's *Yoyogi* (cat. no. 73) and Richard Diebenkorn's *Ochre* (cat. no. 23) are relatively large for woodblock prints, most of the Crown Point prints done in Japan are intimate in scale, works inviting minute examination of the subtleties of tonality produced by the layering of transparent water-based inks.

Such a print is Alex Katz's *The Green Cap* (cat. no. 53). Although considerable criticism has been leveled against Crown Point's program because the artist does not actually cut the block, an examination of the color states of *The Green Cap* reveals the artist's constant participation in the realization of the image. As in the rest of Katz's work, *The Green Cap* can be "read" quickly and has the power, despite its scale, to hold its own on a wall. Remarkable subtleties, however, await the viewer who makes the effort to establish a private dialogue with the work.

Another manifestation of the renewed interest in the small-format, intimate print is *Eldindean Press XVII by XVII,* a portfolio of seventeen miniature intaglio prints by seventeen artists associated with the press. Although the quality of imagery varies considerably, the very fact that the portfolio was published and the enthusiastic public response it has received are indicative of the interest of both artists and connoisseurs in the small black-and-white print that is the antithesis of the large workshop print.

The recent interest in the artist's book, usually considered a rather esoteric medium, points to a return of the print from the wall to the library.

Steve Sorman
Blue 1985
Portfolio of nine prints, incorporating drypoint, monotype, and chine collé; edition of 10
Each drypoint plate: 15.2 x 11.5 cm (6 x 4½ in.)
Each monotype plate: 7.6 x 11.5 cm (3 x 4½ in.)
Each sheet: 48.9 x 39.7 cm (19¼ x 15⅝ in.)
Lent by Dolan/Maxwell Gallery, Pennsylvania Cat. no. 91

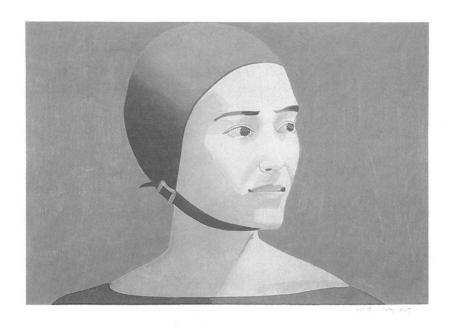

Alex Katz
The Green Cap 1985
Woodblock print; edition of 200
Image: 31.2 x 45.4 cm (12¼ x 17⅞ in.)
Sheet: 44.5 x 61 cm (17½ x 24 in.)
Lent by Crown Point Press, California and New York Cat. no. 53

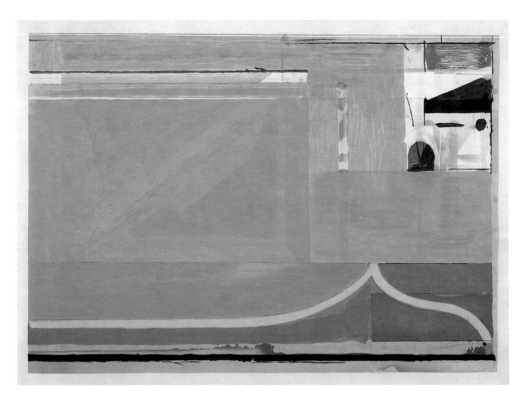

Richard Diebenkorn
Ochre 1983
Woodblock print; edition of 200
Image: 63.3 x 90.9 cm (24⅞ x 35¾ in.)
Sheet: 69.2 x 96.8 cm (27¼ x 38⅛ in.)
Lent by Crown Point Press, California and New York Cat. no. 23

Perusal of an artist's book involves not only sight but touch as well, the tactile pleasure of fine paper. Artists' books are being created for a variety of reasons. Stephen Antonakos's *Book* (cat. no. 4) is a record of his work from 1980 to 1985 in neon. Robert Mapplethorpe's *A Season in Hell* (cat. no. 61), eight photogravures with text, was occasioned by a new translation of Rimbaud's poem by Paul Schmidt. Donald Sultan, who recently published two series of extremely large aquatints with Parasol Press, chose to work in an intimate mode when he collaborated with the playwright David Mamet on *Warm and Cold* (cat. no. 93), an artist's book celebrating the birth of their daughters. No matter how they come into being, however, all artists' books involve the viewer in one-at-a-time active participation.

As a survey exhibition covering the years 1983 to 1985, *Public and Private: American Prints Today* contains a large number, indeed a majority, of works that do not fall conveniently within the extremes of either category. The title of the exhibition is intended to suggest the simultaneous directions American printmaking is currently taking. That two divergent modes can coexist equably indicates the current vitality of the medium. Certain

Dennis Kardon
Charlotte's Gaze 1985
Lithograph and woodcut; edition of 38
Image and sheet: 62.9 x 69 cm (24¾ x 27⅛ in.)
Lent by Echo Press, Indiana Cat. no. 52
Photo: David Keister

works were selected primarily because they support the thesis of the exhibition, but only if they were thought to have their own intrinsic merit. The works that fit neither category were chosen as representative of the broad range of the finest in American printmaking. Interesting prints are being produced throughout the country as new publishers and workshops open in areas distant from the traditional centers of art. Particularly vital new sources are the guest artist programs in which the artist makes a print during his/her stay with professional and student printers. Vernon Fisher's *Hanging Man* (cat. no. 32) was produced under the auspices of the Guest Artists in Printmaking Program at the University of Texas at Austin and Dennis Kardon's *Charlotte's Gaze* (cat. no. 52) was printed and published by Echo Press while he was guest artist at Indiana University, Bloomington.

Works were chosen from viewings and studio visits in the normal course of activity as well as from visits to studios, workshops, and galleries throughout the country specifically for this exhibition. The work of some artists, such as Eric Avery (cat no. 6) was first seen in juried exhibitions, as was the new imagery of an already familiar artist, Frances Myers (cat. no. 66). A generous grant from the Louis Comfort Tiffany Foundation for the acquisition of contemporary American graphics provided a large pool of work from The Brooklyn Museum's permanent collection on which to draw.

As an overview, *Public and Private: American Prints Today* more closely represents the range than the depth of work currently being done in American graphics.

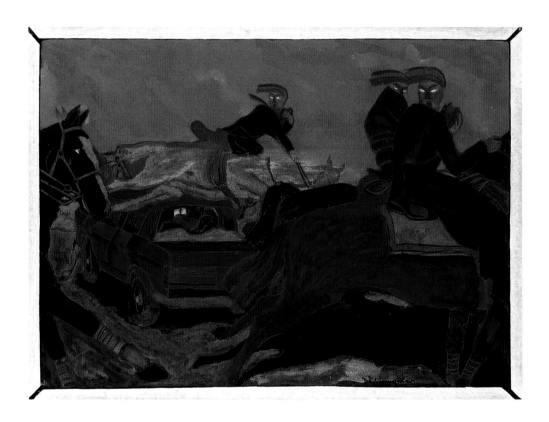

Roberto De Lamonica
Untitled 1984
Monotype; edition unique
Image and sheet: 78.6 x 107.5 cm (31 x 42⅜ in.)
Lent by the artist Cat. no. 20

Terence La Noue
S.F. Monterey Series #8 1985
Monoprint from collograph plates, collage, and hand-coloring with color pencil and pastel; edition unique
Image and sheet: 64.7 x 75.5 cm (25½ x 29¾ in.)
Lent by private collection, Illinois, courtesy of Experimental Workshop, California Cat. no. 58
Photo: Diana Crane

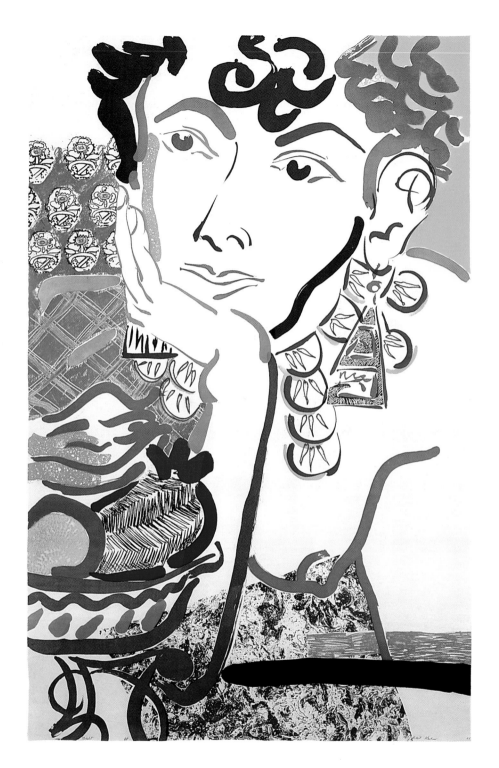

Robert Kushner
Bibelot 1985
Aquatint; edition of 10
Image and sheet: 155.6 x 100.6 cm (61½ x 39⅝ in.)
Lent by Crown Point Press, California and New York Cat. no. 57
Photo: Bill Jacobson

Catalogue

Note:
In the catalogue entries, the collection or lender is given in italics. Several artist's books and portfolios catalogued here list two lenders. This indicates that the exhibition includes two sets, one displayed on the wall or in a case and the other available to the Museum visitor for perusal upon request.

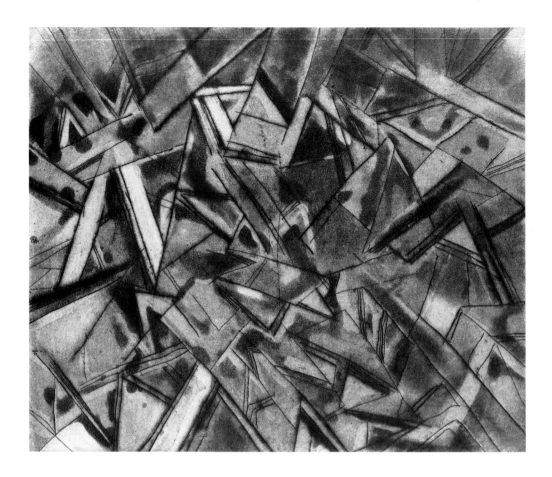

JANET ABRAMOWICZ
Born New York, New York, 1930; lives New York, New York

1 **Metropolis/Rome** 1984–85

Hard-ground etching, aquatint, spit bite, drypoint, and burnishing; edition of 15
Image: 19.9 x 24.5 cm (7¹³⁄₁₆ x 9⅝ in.)
Sheet: 49.5 x 64.8 cm (19½ x 25½ in.)
Paper: Fabriano
Printed by Antonio Sannino at Centro Grafica Contemporanea, Rome.
 Published by the artist
The artist

The staccato, nervous motion of the linear elements of Janet Abramowicz's *Metropolis/Rome* is subverted by the much more painterly use of spit bite and burnishing for the tonal qualities. While the diagonal lines, often forming truncated triangles, impart a somewhat frenzied autographic thrust, suggesting explosive movement, the tonalities create a rhythmic, lyrical play of lights and darks, establishing a tension between the two elements of the composition. Abramowicz opposes the austerity of the hard ground to the sensuousness of the drypoint lines and establishes varieties in tone by using various coarsenesses of aquatint, from large-grained to finely textured. The result is an unstable harmony between the nocturnal quietude and the cacophany of the modern city.

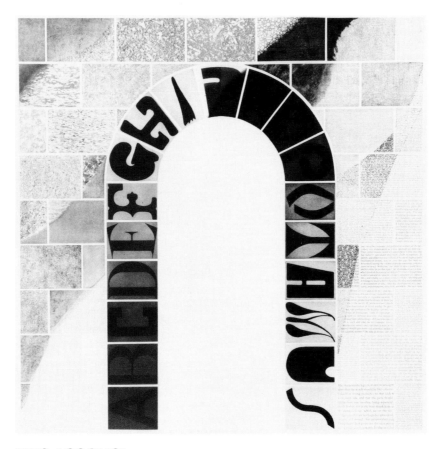

VITO ACCONCI
Born New York, New York, 1940; lives Brooklyn, New York

2 **Building-Blocks for a Doorway** 1983–85

Photo etching, hard-ground etching, soft-ground etching, and aquatint;
 edition of 8
Sixty-two plates of various sizes
Overall: 238.4 x 240 cm (93⅞ x 94½ in.)
Paper: Arches Cover
Photo work by George Holzer. Proofing by Susie Hennessy, John Slivon,
 and Susan McDonough. Additional proofing and editioning by Deli Sacilotto
 and George Holzer at GRAPHICSTUDIO, University of South Florida.
 Coordinated by David Yager. Published by GRAPHICSTUDIO, University
 of South Florida
Carpenter + Hochman, New York
Photo: George Holzer

One of the most ambitious projects that GRAPHICSTUDIO, University of South Florida has ever undertaken, as well as Vito Acconci's most massive and complex print, *Building-Blocks for a Doorway* has required three years of intermittent work, with occasional thoughts by both the studio and the artist of abandoning the project altogether. Composed of sixty-two plates, the scale is life-size, a staggering 8 feet by 8 feet. One of Acconci's major concerns in his sculpture—the interaction of people and architecture—is brought to graphic realization here. Although the viewer may not actually walk through the arch, he/she inevitably projects passage through it. Passage is indeed the key concept, as the arch defines the boundary and connection of two distinct spaces, embodying both the positive and the negative aspects of a wall.

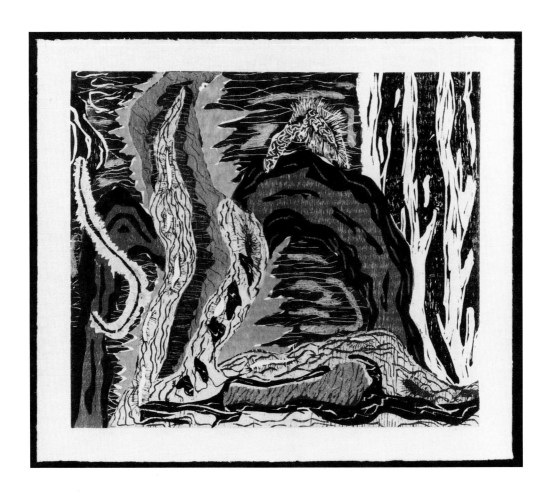

GREGORY AMENOFF
Born St. Charles, Illinois, 1948; lives New York, New York

3 **Chamber** 1985

Woodcut; edition of 35
Image: 80 x 95.3 cm (31½ x 37½ in.)
Sheet: 91.5 x 106.7 cm (36½ x 42 in.)
Paper: Suzuki
Printed by Chip Elwell, Steven Rodriguez, Andrew Bovell, and Alex Kessler.
 Published by Diane Villani Editions
Diane Villani Editions, New York
Photo: ©Steven Sloman

Overall patterning and exuberant use of color are the first elements to strike the viewer of Gregory Amenoff's work. Closer examination reveals abstract landscape, human, and bio-morphic forms, all rendered with an extravagance of gesture. In *Chamber* the rough tex-ture of the woodcut allows Amenoff to stress the expressionistic qualities of his work, while color conveys the decorative balance. The chamber of the title refers to a mountain cave, with its religious and mystical overtones of a hermit's retreat. Amenoff based the print on one of his paintings, *Subterane,* but considerably altered both scale and coloration to trans-form the work into an independent graphic image.

STEPHEN ANTONAKOS

Born Agios Nikolaos, Gypheion, Greece, 1926; lives New York, New York

4 **Book** 1980–85

Screenprint book with cutout and collage; edition of 80
Fifty-two sheets, each sheet 30.5 x 30.5 cm (12 x 12 in.)
Paper: various
Printed by Jo Watanabe at Jo Watanabe. Bound by Gerard Charrière.
 Published by the artist
Both sets: *Joe Fawbush Editions, New York*
Photo: ©Ellen Page Wilson

Somewhere between a diary and photograph album, Stephen Antonakos's *Book* is a journal of his neon installations of 1980–85. Compressed in scale and diagrammed in two dimensions, it distills and concentrates the three-dimensional work in the same way that a snapshot or written record abstracts and isolates selective elements of experience. Antonakos works in a linear vocabulary of formal geometric shapes—the circle and the square— usually breaking these shapes down to their components of right angles and arcs. In *Book,* he is mainly concerned with the arc shape, which he renders both in flat silkscreen and in cutout and collage; this echoes the shallow space of his three-dimensional work.

CHARLES ARNOLDI
Born Dayton, Ohio, 1946; lives Venice, California

5 **Rahway** 1985

Monoprint (wood relief monotype); edition unique
Image and sheet: 228.4 x 188 cm (90 x 74 in.)
Paper: Supra 100
Printed by Joel Stearns and Susan Stearns at New City Editions.
 Published by New City Editions
New City Editions, California

For *Rahway,* a series of forty-six unique prints, Charles Arnoldi cut plywood and masonite blocks which were then relief inked and printed in various combinations and colorations, each unique. As is his custom, Arnoldi often worked on the blocks with a chain saw to achieve a rough, consciously awkward surface texture. Passages of densely overlaid masses alternate with neutral areas bisected by branchlike forms, repeated over the massed areas so that a calligraphic patterning traces its way across the frontal picture plane. The sophistication of Arnoldi's Matisse-like palette belies the deliberate crudeness of the biomorphic forms. The basic composition makes a passing allusion to the log jam paintings of Marsden Hartley's later period.

ERIC AVERY
Born Milwaukee, Wisconsin, 1948; lives San Ygnacio, Texas

6 **False Bacchus** 1985

Photo lithograph, screenprint, linoleum cut, collage, and hand gilding;
 edition of 27
Image and sheet: 81.3 x 110.5 cm (32 x 43½ in.)
Paper: Arches 88
Printed by Michael Hart and Bill Lagattuta at Peregrine Press. Co-published
 by the artist and Peregrine Press
Peregrine Press, Texas

As the first step in the creation of *False Bacchus,* Eric Avery collaged two posters from the Metropolitan Museum's Carravaggio exhibition, placing *Still LIfe with a Basket of Fruit* on the table of *The Supper of Emmaus;* then he added body parts that he had cut from a poster of *Amor Omnia Vincit.* The collage was color-separated and put on four litho plates, on which the artist drew to increase the intensity of the colors. Eight screens were then printed around and over the lithograph to add the shells, leaves, and grapes. The artist then cut a linoleum block, to which the cut body parts were affixed with glue before placing it over the lithograph-silkscreen sheet and printing. When the ink was dry, a template was used to sink the body parts into the paper. Gold leaf was then hand-applied to the arrowhead. The print refers not only to Carravaggio but also to Goya's print after the painting *Bacchus* by Velázquez.

JENNIFER BARTLETT
Born Long Beach, California, 1941; lives New York, New York

7 **Shadow** 1984

Soft-ground etching, aquatint, spit bite, drypoint, and burnishing; edition of 60
Four images and sheets, each 76.2 x 50.8 cm (30 x 20 in.)
Overall: 76.2 x 203.2 cm (30 x 80 in.)
Paper: Fabriano Tiepolo
Plates made by Patricia Branstead. Printed by Simon Draper, Felix Harlan,
 Yong Soon Min, Catherine Tirr, and Carol Weaver at Aeropress.
 Co-published by Paula Cooper and Multiples, Inc.
Multiples, Inc., New York
Photo: ©Geoffrey Clements

In *Shadow,* Jennifer Bartlett once again returns to the pool and statue of her *In the Garden* series, which she has explored with a rigor and thoroughness both intellectually and stylistically that makes the never-ending inventiveness of her achievement so impressive. Typical of her serial approach to printmaking, the image is treated from a slightly different perspective in each of the four panels. This method obviates that her concern is with perception rather than depiction. *Shadow* is her most richly textured, painterly, sensuously colored print to date. The subject has become so familiar — Bartlett's personal icon — that it loses all narrative connotation, becoming instead a meditation in which the variations gain more importance than the theme.

JOHN BEERMAN
Born Greensboro, North Carolina, 1958; lives South Nyack, New York

8 **Untitled (#3)** 1985

Monotype; edition unique
Image: 47.9 x 42.7 cm (18^{13}/$_{16}$ x 16^{13}/$_{16}$ in.)
Sheet: 78.8 x 56.5 cm (31 x 22¼ in.)
Paper: German Etching
Printed by Sylvia Roth at Hudson River Editions. Co-published by the artist
 and Hudson River Editions
Lorence • Monk Gallery, New York
Photo: Eric Pollitzer

One of a series of twelve monotypes on the subject of the beach at East Hampton, *Untitled #3*
is a particularly strong example of John Beerman's compositional abilities as well as of his
impassioned interest in depicting the effects of light and atmospheric conditions. Beerman is
strongly influenced by the American Luminist school, especially the work of Fritz Hugh
Lane, although the square format of the seascapes in this series is quite unlike that of the
Luminists, who usually worked in a format of panoramic horizontals and generally on a much
larger scale. Beerman's technique is to build up layers of transparent inks so that in light areas
the white of the paper is not entirely obscured. Surrounding the central image is a trompe
l'oeil band of marble, its opaqueness emphasizing the luminosity of the seascape.

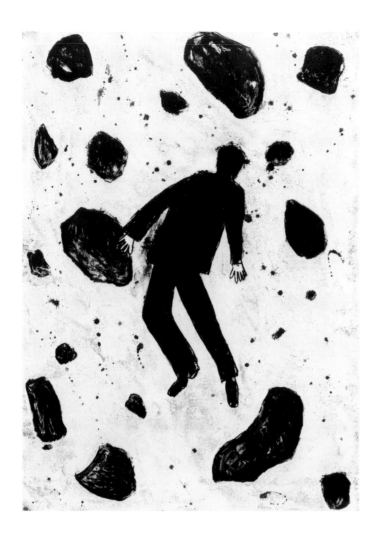

RICHARD BOSMAN
Born Madras, India, 1944; lives New York, New York

9 **Meteor Man** 1985

Lithograph; edition of 28
Image and sheet: 86.3 x 62.2 cm (34 x 24½ in.)
Paper: Mulberry
Printed by John C. Erickson and Marsha Immerman at Anderson Ranch.
 Co-published by the artist and Anderson Ranch
Brooke Alexander, New York
Photo: Ivan Dalla Tana

Unlike Richard Bosman's falling figures in such prints as *Man Overboard,* the figure in *Meteor Man* floats upright in space, beyond the pull of gravity. In this print, Bosman moves from personal to cosmic disaster, from man's confrontation with human-generated menace to impersonal powerlessness on a universal scale. The crayon drawing of the figure and meteors gives the foreground a solidity and mass, while the contrast of the transparent tusche wash of the infinite space and the splatterings of opaque tusche for the distant meteors creates an ineresting play of textures. The gradation of tones from impenetrable black to the most subtle grays confirms Bosman's status as a printmaker who can suggest a whole range of color in classical black and white.

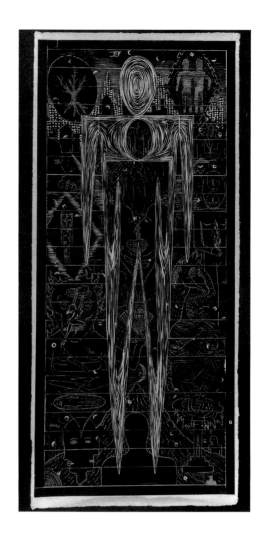

JOHN BUCK
Born Ames, Iowa, 1946; lives Bozeman, Montana

10 **Father and Son** 1985

Woodcut; edition of 30
Image: 203.2 x 90.8 cm (80 x 35¾ in.)
Sheet: 209.5 x 95.2 cm (82½ x 37½ in.)
Paper: Suzuki
Printed by Bud Shark, Barbara Shark, Jean Pless, Roseanne Coachis, and
 Ron Trujillo at Shark's Incorporated. Published by Shark's Incorporated
Shark's Incorporated, Colorado

The dominant image of John Buck's *Father and Son* consists of one highly schematized figure within another, both shown frontally, the outer figure positive, the inner negative. All negative space is filled with small seemingly unrelated human and animal images and symbols, the artist's own private, cabalistic language. At the upper left is an image the artist has previously used in woodcut, a tree whose roots are almost a mirror image of its branches, while at the upper right are two male figures, possibly twins or dual manifestations of one nature. Both self-contained images float in shallow space before a two-dimensional cityscape. The color was chosen to resemble a blueprint, further emphasizing the positive-negative aspects of the image. Regularly spaced horizontal white lines underscore the verticality of the print.

JOHN CAGE
Born Los Angeles, California, 1912; lives New York, New York

11 **Fire #10** 1985

Monotype; edition unique
Image and sheet: 50.8 x 29.2 cm (20 x 11½ in.)
Paper: Twinrocker
Printed by Peter Pettengill and Marcia Bartholme at Crown Point Press,
 Oakland. Published by Crown Point Press
Crown Point Press, California and New York

While the staff of Crown Point Press, armed with fire extinguishers, surrounded the etching press, John Cage set fire to newspapers on the press bed. As dampened paper was placed over the fire and run through the press, it picked up ink from the newspapers at the same time it was scorched and burned at the edges by the fire. Each sheet emerged from its press run affected in a different way by the fire and picking up different, partially legible columns of print from the newspapers. Cage then branded each sheet with the bottom of heated Japanese iron teapots, the number and placement of the resulting rings determined by the *I Ching.* Such an unconventional method of printmaking — where the accurate prediction of the outcome of such a project is impossible — attests not only to Cage's belief in random selecton but also to Crown Point's willingness to be the conduit for the artist's experimentation.

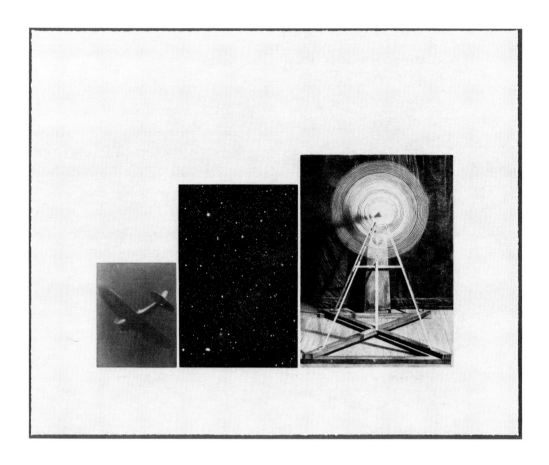

VIJA CELMINS
Born Rija, Latvia, 1939; lives New York, New York

12 Concentric Bearings, D 1984

Drypoint, aquatint, photogravure, mezzotint, and burnishing; edition of 34
Three plates (*left to right*): 11.4 x 9.5 cm (4½ x 3¾ in.),
 20.3 x 13.3 cm (8 x 5¼ in.), 23.5 x 17.8 cm (9¼ x 7 in.)
Sheet: 45.7 x 56.8 cm (18 x 22⅜ in.)
Paper: Rives BFK
Printed by Doris Simmelink and Ken Farley at Gemini G.E.L.
 Published by Gemini G.E.L.
Gemini G.E.L., California and New York
Photo: ©Gemini G.E.L., Los Angeles, California

In *Concentric Bearings, D,* Vija Celmins utilizes three discrete images that have the same base line but increase in height and width in an irregular step pattern. The center image is based on a NASA observatory photograph that the artist re-drew on a plate with drypoint and aquatint, representing stars at vastly different levels in infinite space on a two-dimensional plane. Flanking the constellation of the center plate are two objects theoretically in motion, an airplane and a Duchamp rotorelief, but frozen by the act of picture-making. Both objects are also derived from photographs, the rotorelief a photogravure retouched with the drypoint, aquatint, and burnishing; the airplane based on a found photograph worked on the plate with mezzotint. The relative scale of all three images belies the actual scale of each; they are related in that each is a chart of depth and motion.

LOUISA CHASE
Born Panama City, Canal Zone, 1951; lives New York, New York

13 **Portfolio of Six Untitled Etchings** 1984

Drypoint, aquatint, and spit bite; edition of 30
Image: 12.7 x 15.2 cm (5 x 6 in.)
Sheet: 28 x 28 cm (11 x 11 in.)
Paper: Somerset
Processing and proofing by Felix Harlan and Carol Weaver at Harlan/Weaver.
 Editioning by Sally Mara Sturman and Jane Kent. Published by
 Diane Villani Editions
Both sets: *Diane Villani Editions, New York*

Louisa Chase's untitled portfolio has the intimacy and immediacy of a sketchbook of notations, an insight into the artist's development of ideas. Drypoint is a very direct method, for the artist cuts directly into the plate rather than drawing through a ground, as in etching. Although working on copper provides a strong resist, the artist can vary her line with more immediately visible results than in standard etching techniques. In this case, Chase uses the linear properties of drypoint to draw disconnected body parts, usually hands, as well as free lines to form a nexus loosely connecting the disparate sketches. Painterly strokes of spit bite create tonal echoes of the linear elements and enrich certain segments of the drypoint lines to create an overall rhythm.

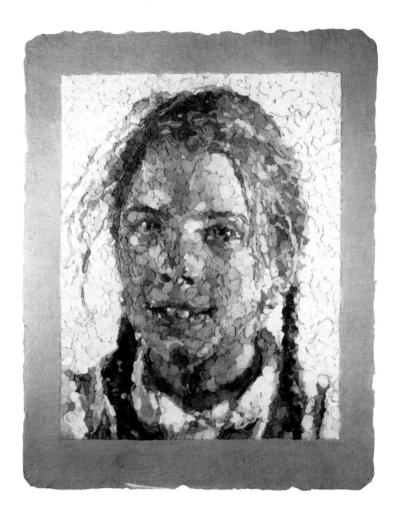

CHUCK CLOSE
Born Monroe, Washington, 1940; lives New York, New York

14 **Georgia** 1984

Handmade paper multiple; edition of 35
Image: 119.4 x 94 cm (47 x 37 in.)
Sheet: 142.3 x 111.8 cm (56 x 44 in.)
Paper: 100% cotton rag paper handmade by Joseph Wilfer of Austin Paper
 Works in forty different values of gray
Published by Pace Editions
Pace Editions, New York

Always unconventional and experimental in both his paintings and his prints, Chuck Close, in deciding to translate a glued paper chip portrait of his daughter Georgia into a multiple, bypassed the traditional media. He had a template made of lozenge-shaped compartments of soldered strips of thin brass which could be filled with paper pulp in varying values of gray, emptied, and repeated to build an edition. This technique is a logical extension of Close's grid-based portraits in which he has experimented with a remarkable variety of markings, including inked fingerprints. The rough texture of handmade paper pulp and the coolness of the grissage, along with Close's detached, analytical style, keeps the image completely unsentimental.

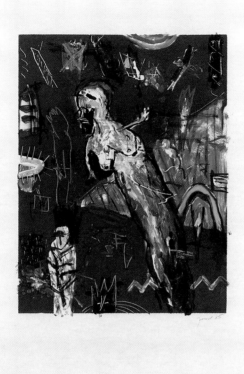

FORD CRULL
Born Boston, Massachusetts, 1952; lives New York, New York

15 **The Prophet** 1985

Monotype; edition unique
Image: 45.1 x 35 cm (17¾ x 13¾ in.)
Sheet: 76.2 x 55.9 cm (30 x 22 in.)
Paper: Rives BFK
Printed by Cheryl Pelavin at Pelavin Editions, New York.
 Published by Pelavin Editions
Joyce and Kenneth Ketay, New York, courtesy of Jay Gallery, New York
Photo: D. James Dee

Columnar forms, some human, some less specific, float unanchored through indeterminate space in Ford Crull's *The Prophet*. The foremost figure, its spatial relationship established by its position in front of the large, architectonic triangular form, is androgynous, having breasts and a beard. The reference is clearly to Tiresias, the Theban seer blinded by Athena, who later took pity on him and gave him prophetic vision to compensate for the disability she had caused. In order to experience female sexuality, Tiresias turned himself into a woman, later reverting to his male form but maintaining some female characteristics. The imagery of Crull's print is dreamlike, with phantasmagorical forms floating through space as freely associative symbols. Like an oracle, Crull expresses himself in parables.

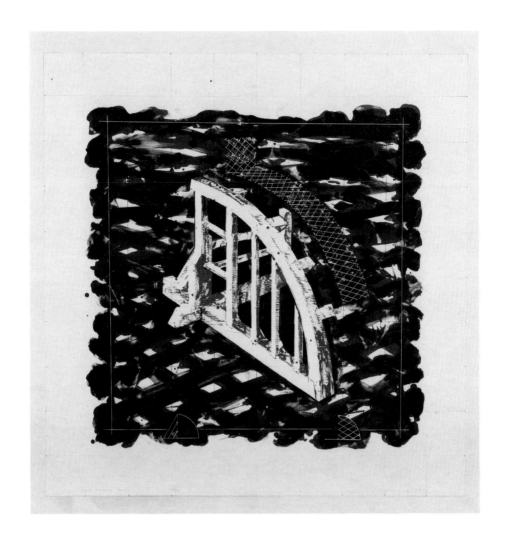

ROBERT CUMMING
Born Worcester, Massachusetts, 1943; lives West Suffield, Connecticut

16 **Two Frame Arc** 1985

Lithograph and screenprint; edition of 65
Image: 92.7 x 88.9 cm (36½ x 35 in.)
Sheet: 100.3 x 96.5 cm (39½ x 38 in.)
Paper: Arches Cover
Printed by Richard Hammond and David Udoff at Cirrus Editions.
 Co-published by Castelli Graphics, Cirrus Editions, and Derrière L'Etoile
 Studios
Castelli Graphics, New York
Photo: Eric Pollitzer

In addition to being a photographer and conceptual artist of note, Robert Cumming is also an astonishing draftsman, whose first mature venture into printmaking seems long overdue. In *Two Frame Arc,* he places a schematic rendering of a joined double arc in a context of broadly brushed perspective grids, calling attention in a tongue-in-cheek way to the conventions of perspective and the central problem of flat art: the illusion involved in rendering three-dimensional imagery in a two-dimensional medium. His framing of the image calls further attention to his concern with the illusions and conventions of representational art.

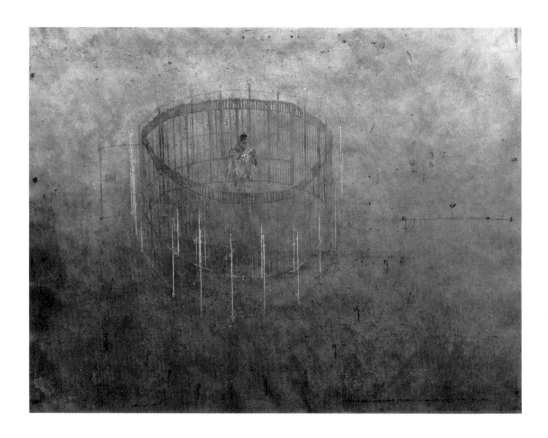

DEAN DASS
Born Hampton, Iowa, 1955; lives Charlottesville, Virginia

17 **Within–Without** 1985

Monoprint (etching with hand-coloring in gouache over dry pigment and
 gouache); edition to be determined
Image: 59.4 x 78.8 cm (23⅜ x 31 in.)
Sheet: 62.5 x 78.8 cm (24⅝ x 31 in.)
Paper: Sekishu
Printed and published by the artist
Dolan/Maxwell Gallery, Pennsylvania

By preparing his paper with dry pigment and gouache, Dean Dass creates an almost organic surface, as if he were printing on a support of painted earth. Neither the figure — an anatomical study of muscles and sinews — nor the circular cage that encloses him has a definite grounding, and, although the gradation of color from dark at the bottom to light at the top hints at a transformation from earth to sky, no horizon line clearly marks the conjunction. The curved tops of the bars of the cage are echoed by a semicircle of curved prongs in the foreground, as if the artist were hinting at a cage within a cage. A rectangle projecting from the left of the cage suggests an open door, but it does not interrupt the circle of bars. The legend in the lower right reads "He starts to make a world of himself/he starts to rise above this world within and without."

MICHAEL DAVID
Born Reno, Nevada, 1954; lives New York, New York

18 **Untitled #8** 1985

Monoprint, hand-colored with oil paint; edition unique
Image and sheet: 30.5 x 40.6 cm (12 x 16 in.)
Paper: Experimental Workshop linen rag handmade paper
Printed by Wil Foo at Experimental Workshop. Published by Experimental
 Workshop
Experimental Workshop, California
Photo: Diana Crane

Michael David's untitled monoprint, one of a series of nine, calls into question the point at which a hand-colored image ceases to be a print and becomes a painting on paper. David gouged a winglike form into a zinc plate, thus grounding the resulting impressions in print-making, although not of a traditional nature. The plate was then inked as a monotype and printed. David painted into the residual ink on the plate for each cognate impression, after which he then painted over most of the printed surface, directly on the sheet. The oil paint creates an entirely different surface than one is used to seeing in prints. Such extensive re-working in oil paint rather than ink obscures most of the printmaking qualities, yet the gouged image remains, maintaining the link with the transfer process that is the essence of printmaking.

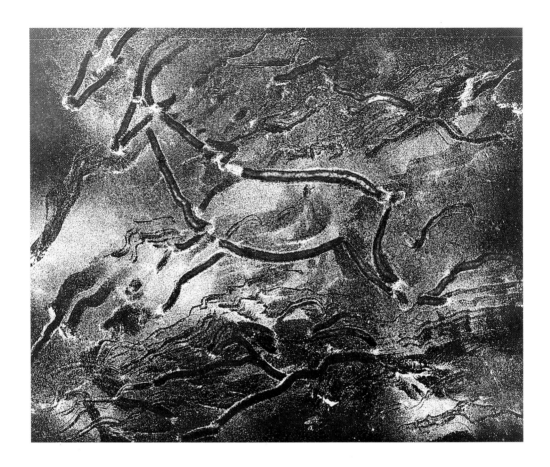

ELAINE DE KOONING
Born New York, New York, 1920; lives East Hampton, New York

19 Torchlight Cave Drawings 1985

Portfolio of eight aquatints; edition of 25
Each image: 30.2 x 37.5 cm (11⅞ x 14¾ in.)
Each sheet: 50.8 x 66.7 cm (20 x 26¼ in.)
Paper: Richard de Bas
Printed by Peter Pettengill at Crown Point Press, Oakland.
 Published by Crown Point Press
Both sets: *Crown Point Press, California and New York*

The image illustrated here is *Torchlight Cave Drawing II.*

The word "drawing" in Elaine de Kooning's portfolio of eight aquatints *Torchlight Cave Drawings* is a precise description of her technique. Each plate was grounded with the rosin powder used for aquatint, and de Kooning drew with her finger to displace the powder, an unusual and highly autographic technique that created remarkable nuances of lights and darks. The images derive from Paleolithic cave paintings near Les Eyzies in southern France. The cave paintings almost certainly have a religious basis; they may have been icons painted to honor and propitiate the gods of the hunt. As in the cave paintings, the figures in each of de Kooning's prints often overlap. With the velvety dark field of aquatint, she re-creates the darkness of the caves where, centuries ago, the paintings were revealed only by the flickering light of torches.

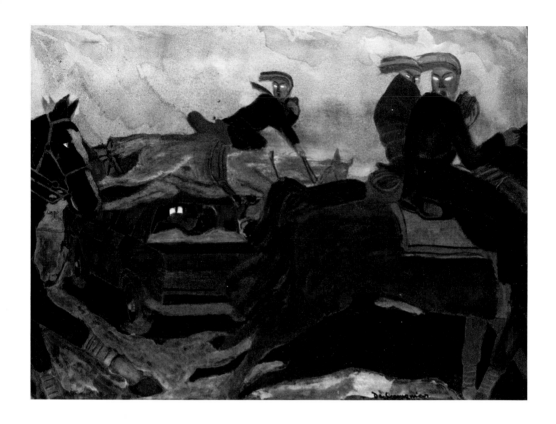

ROBERTO DE LAMONICA
Born Ponta Pora, Mato Grosso, Brazil, 1933; lives Staten Island, New York

20 **Untitled** 1984

Monotype; edition unique
Image and sheet: 78.6 x 107.5 cm (31 x 42⅜ in.)
Paper: German Etching
Printed and published by the artist
The artist

Roberto De Lamonica's untitled monotype is one of a series dealing with the plight of the artist in the modern world. All of the monotypes include frames as part of the composition, serving simultaneously to emphasize the print as artifact and to distance the viewer. De Lamonica's perception of the artist is essentially romantic: the man apart from (and usually persecuted by) society. The artists in this instance are fleeing on horseback from an undefined cataclysmic event; each of them clutches a pencil sharpener, an ironic comment on the artist's most basic tool for drawing, the one tool that can and must be salvaged. Despite their headlong flight, all are looking back. Modern civilization pursues them in a pickup truck. A distinctive technical feature of De Lamonica's monotypes is the varnished surface, like a painting's, applied to the plate and transferred in the second press run.

MARTHA DIAMOND
Born New York, New York, 1944; lives New York, New York

21 **Manhattan Suite** 1985

Portfolio of five screenprints; edition of 36
Each image and sheet: 57.1 x 50.8 cm (22½ x 20 in.)
Paper: *Windows:* Arches 140 lb. Hot Press, *Construction:* Saunders Hot
 Press, *Cornice:* Rives BFK, *High Rise:* Arches 140 lb. Hot Press,
 Pediment: Rives Papier de Lin
Printed by Hiroshi Kawanishi, Kenjiro Nonaka, and Jon Kranczuk at Simca
 Print Artists, Inc. Co-published by the artist and Simca Print Artists, Inc.
The artist

The image illustrated here is *Construction.*

The genesis of *Manhattan Suite* was Martha Diamond's intention to make a screenprint by building form through the overlapping of extremely transparent inks rather than the traditional edge-to-edge registation, in which the image is taken apart and re-assembled like a jigsaw puzzle. The initial results were so successful that a suite of five seemed to evolve naturally. Diamond's style can best be described as painterly constructivism in a representational idiom. Although remaining within the architectonic mode, in her most recent work her major concern has shifted to the depiction of light and air within the structures. The transparency of the inks succeeds in realizing this concern, as well as in establishing a remarkably subtle range of tonalities. Different papers were used for the different images because the ink reacted differently to each surface.

JANE DICKSON
Born Chicago, Illinois, 1952; lives New York, New York

22 **Mother and Child** 1984

Aquatint; edition of 45
Image: 76.3 x 43.2 cm (30 x 17 in.)
Sheet: 90.7 x 58.4 cm (35¾ x 23 in.)
Paper: Rives BFK
Printed by Gregory Burnet and Maurice Payne at Maurice Payne.
 Published by Maurice Payne
Joe Fawbush Editions, New York

From her studio overlooking Times Square, Jane Dickson paints what she sees from her windows, thus accounting for the overhead perspective and accentuated verticality of format in much of her work. The light more often comes from neon than from any natural source in this nocturnal neighborhood, so her palette tends toward acidic greens and yellows or warm neon blues and purples. In *Mother and Child,* Dickson reverses her perspective, looking up from the stairway of a subway exit at a young mother dragging a child in a stroller up the steps, a quintissentially urban image. Because of the perspective, the child looms massive, almost monstrous, while the deliberately awkward drawing of the mother emphasizes her struggle. Eschewing etched outlines, the artist drew directly with aquatint, which resembles the texture of her oilstick paintings on textured rubber.

RICHARD DIEBENKORN
Born Portland, Oregon, 1922; lives Santa Monica, California

23 **Ochre** 1983

Woodblock print; edition of 200
Image: 63.3 x 90.9 cm (24⅞ x 35¾ in.)
Sheet: 69.2 x 96.8 cm (27¼ x 38⅛ in.)
Paper: Mitsumata
Printed by Tadashi Toda in Kyoto, Japan. Published by Crown Point Press
Crown Point Press, California and New York

Ochre is easily one of the richest and most seductive of Richard Diebenkorn's color prints based on abstract landscape imagery. The traditional Japanese woodblock techniques, in which master artisans cut blocks based on a watercolor or gouache maquette provided by the artist and then ink the blocks with water-based inks, beautifully translates Diebenkorn's buildup of semitransparent color. The eye travels slowly over the print, noting the subtleties of each component of the complex composition. Compared to the density and opacity of his intaglio work, *Ochre* has a lighter, more airy quality, despite its overall composition. Color, design, and texture all blend in lyrical harmony.

50

JIM DINE
Born Cincinnati, Ohio, 1935; lives New York, New York

24 The French Watercolor Venus 1985

Soft-ground etching, engraved with power tool and hand-colored; edition
 of 8
Image: 86.4 x 66.1 cm (34 x 26 in.)
Sheet: 105.8 x 80.7 cm (41⅝ x 31¾ in.)
Paper: Rives BFK
Printed by Aldo Crommelynck at Atelier Crommelynck. Published by Pace
 Editions
Pace Editions, New York

The collaboration of Jim Dine and Aldo Crommelynck is as fortuitous as it was inevitable. Dine has long been established as perhaps the most inventive and varied American print-maker working in intaglio of his time, while Crommelynck is France's greatest intaglio printer. *The French Watercolor Venus* treats a relatively recent image in Dine's printmaking vocabulary, the Venus de Milo, in soft-ground etching, the technique in which one can achieve the softest, most grainy line. He then enhanced and emphasized certain lines by cutting into the plate with a power tool, creating a rhythm of hard and soft lines. Passages of highly diluted water-color veil the image without obscuring line. *The French Watercolor Venus* has a presence and immediacy remarkable even for Dine.

CARROLL DUNHAM
Born New Haven, Connecticut, 1949; lives New York, New York

25 **Untitled** 1985

Lithograph; edition of 31
Image and sheet: 62.8 x 45.7 cm (24¾ x 18 in.)
Paper: Jeff Goodman handmade paper
Printed by Keith Brintzenhofe at Universal Limited Art Editions, Inc.
 Published by Universal Limited Art Editions, Inc.
Private collection, Texas, courtesy of Butler Gallery, Texas

By outlining a rectangular image area and then deliberately violating its boundaries, Carroll Dunham negates the picture plane that he has established, calling attention to the artifice involved in the conventions of two-dimensional image-making. The left side of the border contains the image; while on the right, fragments of autographic lines and circles that appear to float upward like bubbles exceed the double-line boundary, continuing into space in two-dimensional actuality and three-dimensional illusionism. As in his paintings and drawings, Dunham, in his prints, explores a wide range of marking techniques, juxtaposing realized forms that imply three-dimensionality with pure line that bespeaks only its linear property. The implied torque of the phallus-like shape provides a central force for the linear motion throughout the image.

8. David Finkbeiner

26 **Eldindean Press XVII by XVII** 1985

A portfolio of 17 miniature intaglio prints with foreword by Gerrit Henry,
 all printed at and published by Eldindean Press in 1985
Each sheet: 21.6 x 19.1 cm (8½ x 7½ in.)
Edition of 100
Two sets: *Eldindean Press, New York*

1. **ALLEN BLAGDEN**
Born New York, New York, 1938; lives
 Salisbury, Connecticut
Island Sheep 1985
Etching, aquatint, and drypoint
Image: 4.2 x 6 cm (1⅝ x 2⅜ in.)
Paper: Rives BFK
Printed by Ariel Taylor Norton

2. **LORRAINE BODGER**
Born New York, New York, 1946; lives
 New York, New York
Family at Home 1985 (illustrated)
Etching and aquatint
Image: 5 x 6.8 cm (1¹⁵⁄₁₆ x 2¹¹⁄₁₆ in.)
Paper: Somerset Textured White
Printed by Ariel Taylor Norton

3. **WARREN BRANDT**
Born Greensboro, North Carolina,
 1918; lives New York, New York
Domestic Scene 1985
Etching and drypoint
Image: 4.8 x 6.3 cm (1⅞ x 2½ in.)
Paper: Fabriano Tiepolo
Printed by Ariel Taylor Norton

2. Lorraine Bodger

4. **BYRON BRATT**
Born Everett, Washington, 1952; lives
 Everett, Washington
Food for Thought 1985
Sandpaper aquatint, drypoint, and
 roulette
Image: 5.4 x 6.7 cm (2⅛ x 2⅝ in.)
Paper: Arches Johannot
Printed by Anthony Kirk

11. Yvonne Jacquette

5. **RUDY BURCKHARDT**
Born Basel, Switzerland, 1914; lives
New York, New York
In the Grass 1985
Etching
Image: 4.8 x 7.4 cm (1⅞ x 2⅞ in.)
Paper: German Etching
Printed by Ariel Taylor Norton

6. **ROBERT COURTRIGHT**
Born Sumter, South Carolina, 1926;
lives New York, New York, and Opio,
France
Aeolian Mask 1985
Etching and aquatint
Image: 6.7 x 5.4 cm (2⅝ x 2⅛ in.)
Paper: Rives Heavyweight
Printed by Ariel Taylor Norton

7. **KEVIN FALCO**
Born Neptune, New Jersey, 1956;
lives New York, New York
fierce, innocent, ???... 1985
Etching, aquatint, and drypoint
Image: 7.3 x 5.7 cm (2⅞ x 2¼ in.)
Paper: J. Perrigot Arches
Printed by Anthony Kirk

8. **DAVID FINKBEINER**
Born Tillomook, Oregon, 1936; lives
Garrison, New York
Through the Glass 1985 (illustrated)
Roulette and drypoint
Image: 5.1 x 7.3 cm (2 x 2⅞ in.)
Paper: Lana Gravure
Printed by Ariel Taylor Norton

9. **JOE GIORDANO**
Born Baltimore, Maryland, 1942; lives
New York, New York
Biplane 1985
Etching and aquatint
Image: 5.1 x 8.3 cm (2 x 3¼ in.)
Paper: Arches Cover
Printed by Ariel Taylor Norton

10. **CHARLES HEWITT**
Born Auburn, Maine, 1946; lives New
York, New York
Summer Night 1985 (illustrated)
Etching, aquatint, and drypoint
Image: 5.1 x 6.7 cm (2 x 2⅝ in.)
Paper: Rives BFK
Printed by Ariel Taylor Norton

11. **YVONNE JACQUETTE**
Born Pittsburgh, Pennsylvania, 1934;
New York, New York
Sanitation Truck 1985 (illustrated)
Etching
Image: 4.5 x 5.5 cm (1¾ x 2³⁄₁₆ in.)
Paper: Magnani Incisioni
Printed by Ariel Taylor Norton

12. **ANTHONY KIRK**
Born Bonnyrigg, Midlothian, Scotland,
1950; lives New York, New York
Peaks 1985
Engraving and drypoint
Image: 7 x 6 cm (2¾ x 2⅜ in.)
Paper: J. B. Green Crisbrook
Printed by the artist

13. **ROBERT ANDREW PARKER**
Born Norfolk, Virginia, 1927; lives
West Cornwall, Connecticut
A Spotted Hyena 1985
Etching and aquatint
Image: 5.1 x 6 cm (2 x 2⅜ in.)
Paper: Lana Gravure
Printed by Ariel Taylor Norton

14. **DAVID SAUNDERS**
Born New York, New York, 1954; lives
New York, New York
Met 1985
Etching and aquatint
Image: 8.9 x 5.1 cm (3½ x 2 in.)
Paper: Somerset Soft White
Printed by Anthony Kirk

15. **KARL SCHRAG**
Born Karlsruhe, Germany, 1912; lives
New York, New York
Sunflowers and Moon 1985
Etching and engraving
Image: 4.5 x 6.7 cm (1¾ x 2⅝ in.)
Paper: T. H. Saunders
Printed by Anthony Kirk

10. Charles Hewitt

16. **PHILIP SMITH**
Born Miami, Florida, 1952; lives New
York, New York
Bowing Man 1985
Aquatint
Image: 2.3 x 6.2 cm (⅞ x 2⁷⁄₁₆ in.)
Paper: Somerset Textured White
Printed by Anthony Kirk

17. **ALTOON SULTAN**
Born Brooklyn, New York, 1948; lives
New York, New York
Eleuthera 1985
Drypoint
Image: 3.8 x 6 cm (1½ x 2⅜ in.)
Paper: Somerset Soft White
Printed by Anthony Kirk

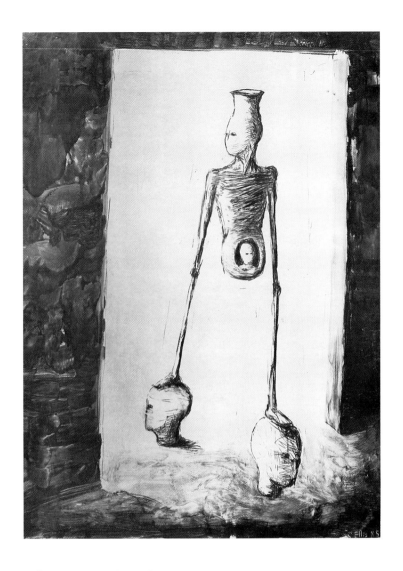

JONATHAN ELLIS
Born Washington, D.C., 1953; lives New York, New York

27 **Mook Woman** 1985

Monotype; edition unique
Image and sheet: 108.5 x 79.2 cm (42¾ x 31¼ in.)
Paper: Ivory
Printed by Sylvia Roth and Susan Mallozzi at Hudson River Editions.
 Co-published by the artist and Hudson River Editions
The artist

In his sculpture, drawings, and monotypes, Jonathan Ellis brings a contemporary science-fiction sensibility to bear on the roots of Giacometti-inspired surrealism. "Mooks" are recurring characters in his repertory of humanoid figures whose heads are vases and whose arms function as legs. In her open womb, *Mook Woman* bears an embryonic version of the same mummy-like heads upon which she steps, regenerating her peculiar necessities within her own truncated body. The mood is ambiguous, at once melancholic and dreamlike, subject to speculation rather than interpretation. The loosely applied washes that frame the central image emphasize the linear depiction of the figure.

DONALD FARNSWORTH
Born Palo Alto, California, 1952; lives Oakland, California

28 Counterpoint Series/Quatrefoil 1985

Chine collé with lithograph, monotype, and inclusions of various handmade
 papers, silver leaf and gold leaf, and hand-coloring with pencil; edition
 unique
Image and sheet: 76.2 x 55.9 cm (30 x 22 in.)
Paper: Kozo collé on Stonehenge
Printed by the artist at Magnolia Editions. Published by Magnolia Editions
Magnolia Editions, California

As in all Donald Farnsworth's work, the aesthetic premise of *Counterpoint Series/Quatrefoil*
is the conjoining of oriental and occidental imagery and techniques. Manipulating formal
and symbolic elements, Farnsworth utilizes pieces of antique paper scribbled with Japanese
calligraphy and combines them with lithographic renderings of Western (in this case, Gothic)
architecture. The series title refers to the musical texture resulting from the combining of
individual melodic lines, while the specific title refers to the four-lobed ornament in the apex
of the arch. Farnsworth, who is a papermaker as well as a printer and printmaker, is particularly
sensitive to the nuances of oriental papers, embedding them in his own handmade paper as
a compositional as well as a decorative element.

57

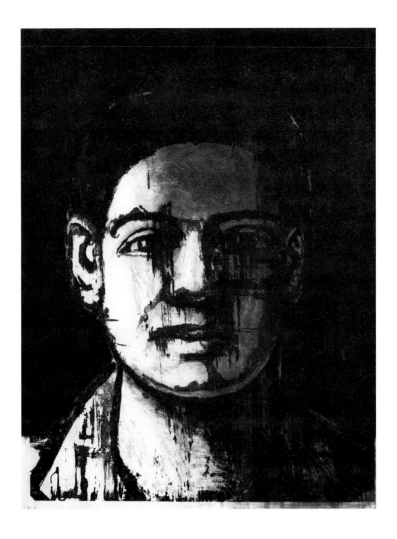

AARON FINK
Born Boston, Massachusetts, 1955; lives Boston, Massachusetts

29 **Portrait I** 1984

Etching with sugar lift and aquatint, hand-colored with red india ink and
 black oilstick; edition unique
Image and sheet: 80.4 x 62.9 cm (31⅝ x 24¾ in.)
Paper: Tumba Grafik
Printed by the artist at Center Street Studio, Gloucester, Massachusetts.
 Published by the artist
Victoria Munroe Gallery, New York

An almost sculptural presence and monumentality characterize Aaron Fink's portrait etch-
ings. In *Portrait I,* the bust figure is positioned head on, cropped at the shoulders, but with
indeterminate space surrounding the head, producing a clear definition of figure and ground.
Fink uses a thick, inflected line, with variations in weight achieved by various depths of
biting. By arbitrarily lighting the left side of the face and neck, the artist gives the portrait an
inflection from positive to negative. The light areas, particularly in the nose and neck, have
a scraped, irregular texture, with an especially painterly demarcation between light and
shadow in the neck. The variations in opacity of the red wash on the figure create further
textural interplay.

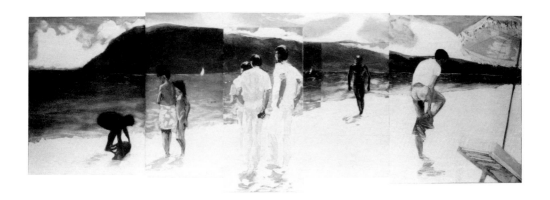

ERIC FISCHL
Born New York, New York, 1948; lives New York, New York

30 **Year of the Drowned Dog** 1983

Etching with aquatint and drypoint; edition of 35
Six sheets of various sizes
Overall: 63.5 x 177.8 cm (25 x 70 in.)
Paper: Zerkall
Printed by Peter Kneubühler in Zurich, Switzerland. Published by Peter
 Blum Edition
The Brooklyn Museum 83.224.1–6, Frank L. Babbott Fund

Year of the Drowned Dog consists of two tripartite components. The first is a triptych that forms a beach panorama, complete in itself. The second component consists of three separate smaller sheets that may be affixed to the center panel to overlap the panorama. The physical act of assembling the entire print adds further narrative layering as each of the smaller sheets (the two native children, the three sailors, the man walking toward the viewer) is affixed to this Caribbean beach scene. Significantly, in each additive sheet, none of the figurative groups relates to either of the others, although the two children do observe the native figure in the left panel of the panorama as he crouches over the drowned dog. When assembled, the shape of the piece is irregular, underscoring the fact that, although narrative, *Year of the Drowned Dog* does not present a cohesive, linear development but rather an arrangement of fragments that do not entirely adhere. Fischl forces the viewer to connect the segments and draw his/her own interpretation.

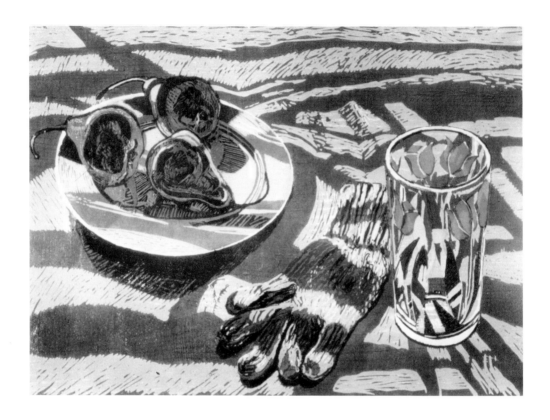

JANET FISH
Born Boston, Massachusetts, 1938; lives New York, New York

31 **Pears and Mitten** 1985

Woodcut; edition of 45
Image and sheet: 49.5 x 70.5 cm (19½ x 27¾ in.)
Paper: Sekishu
Printed by Chip Elwell, Andrew Bovell, and Steven Rodriguez at Chip
 Elwell. Published by 724 Prints, Inc.
724 Prints, Inc., New York

Because of her bravura painting technique, the choice of woodcut as a printmaking medium by Janel Fish is surprising but, in the case of *Pears and Mitten,* wholly fortuitous. The still life, shown up close from a narrowly downward angle, induces one to re-examine the properties of the very ordinary objects depicted. The mitten, which is light-absorbent, divides the glass (transparent, except for the opaque tulip figuration) from the reflective surface of the plate. The precise rendering of the objects contrasts sharply with the loose, fluid ground on which they rest, a blue cloth reminiscent of sea water in which Fish uses the wood grain to enhance the undulating quality of the casually draped cloth.

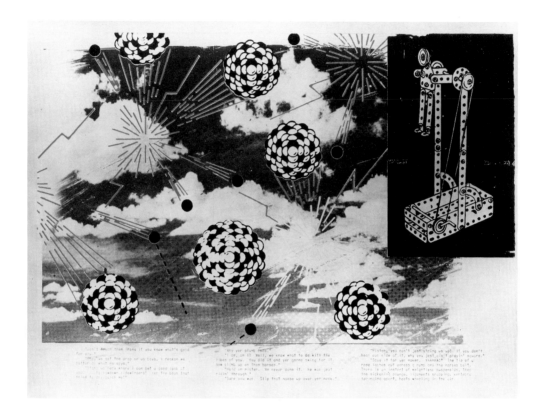

VERNON FISHER

Born Fort Worth, Texas, 1943; lives Fort Worth, Texas

32 **Hanging Man** 1984

Lithograph and serigraph; edition of 40
Image and sheet: 66 x 91.5 cm (26 x 36 in.)
Paper: Arches Cover White
Printed by Kenneth J. Hale, Tim High, Alisa Vance, Ann Chamberlain,
 Kelly Hughes, Judith O'Rourke, and Alan Moyes at the University of
 Texas at Austin. Published by Guest Artists in Printmaking Program at
 the University of Texas at Austin
Butler Gallery, Texas

The main image of Vernon Fisher's *Hanging Man* is a forecast of ultimate destruction from "star wars" technology. Across a peaceful sky, atomic structures raid and counterraid. The inset image of an erector set construction of a figure on a gallows provides a bridge to the seemingly unrelated narrative at the bottom, where Fisher has written a scene of frontier justice in B-movie western dialogue. Although no one is identified, the situation is evidently one man about to lynch a group who may or may not be guilty of the unspecified crime he accuses them of. The final two sentences are in straightforward prose that describe their death by hanging in language that is vivid yet detached. The connection to a President who once played in B Westerns and is now capable of "lynching" the whole of mankind is easy to draw.

SAM FRANCIS
Born San Mateo, California, 1923; lives Santa Monica, California

33 **Untitled** 1985

Sugar lift, aquatint, and spit bite; edition of 30
Image: 22.5 x 18.7 cm (8⅞ x 7⅜ in.)
Sheet: 40.7 x 34.3 cm (16 x 13½ in.)
Paper: Somerset Satin
Printed by Jacob Samuel, at The Litho Shop, Inc. Published by The Litho
 Shop, Inc.
The Litho Shop, Inc., California
Photo: Susan Einstein

The imploding form of Sam Francis's untitled sugar-lift and spit-bite aquatint sets up strong tensions with all the edges and corners of the plate. The image has an energy and authority that far exceed its constricted, intimate scale. Francis creates a further rhythmic play of textures among the light-reflecting properties of the metallic pigments of gold, copper, and aluminum, the opacity of the black, and the diluted, semi-transparent washes of color. The central, quatrefoil-shaped form lies in indeterminate space, both overlaying and underlaying the gestural lines and splatters of the surrounding field. Working with two methods of applying aquatint, both of which entail the use of a brush, Francis has achieved a glowingly painterly image, a late twentieth-century icon.

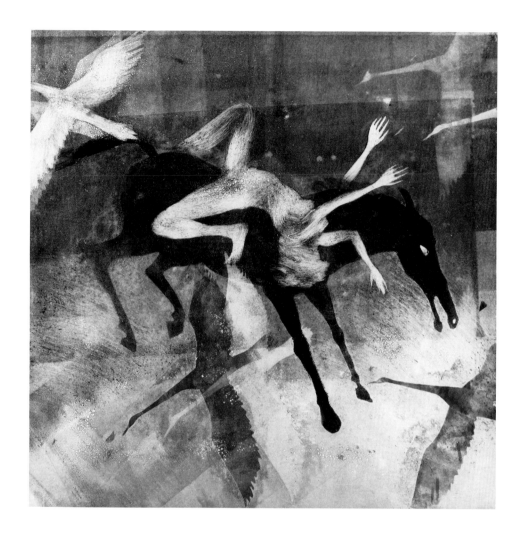

MARY FRANK
Born London, England, 1933; lives New York, New York

34 **Astronomy** 1985

Monotype; edition unique
Image and sheet: 71.1 x 71.1 cm (28 x 28 in.)
Paper: Arches
Printed and published by the artist
The artist

Since she usually works in series of monotypes, Mary Frank has become especially adept at manipulating remnants of ink on the plate to establish a subtly modulated field that is rich in texture and color, in this case a purplish wine red that ranges from transparent to almost opaque. The bird figures are cutouts, either inked and printed additively or used subtractively to stop out ink. The horse is another cutout, inked and transferred to the plate, while the cutout of the falling human figure acts as a resist, over which the artist works a very thin film of transparent ink in broad gestures. The image has both mythical and dreamlike qualities, as birds, horse, and figure soar through uncharted celestial space.

HARRY FRITZIUS
Born Blytheville, Arkansas, 1932; lives San Francisco, California

35 **Untitled** 1985

Monoprint (woodcut with collage); edition unique
Three images and sheets *(left to right):* 87.8 x 57 cm (34⅝ x 22½ in.),
 87.8 x 53.3 cm (34⅝ x 21 in.), 87.8 x 53.6 cm (34⅝ x 21⅛ in.)
Overall: 87.8 x 163.9 cm (34⅝ x 64½ in.)
Paper: various
Printed and published by the artist
Private collection, New York, courtesy of Bruce Velick Gallery, California

This untitled monoprint's triptych format, a structural device often used in devotional works ranging in scale from altarpieces to portable paintings, is the first clue to its religious and mystical associations. The variations of the image wrought by different inkings and collage have a liturgical quality, repetitive like a litany of praise or invocation. The image is a reference to Edvard Munch's *The Kiss,* in which physical love is portrayed as simultaneously tender and rapacious. Munch's woodcuts inform Fritzius's graphic work, for he strives to achieve the Norwegian artist's effect of "painting with wood." The collaged element in the central panel that fractures the image and creates another spatial plane is torn from another impression taken from the same block. Fritzius's monoprint has a Byzantine richness and an intense iconic power.

MICHAEL GLIER
Born Fort Thomas, Kentucky, 1953; lives New York, New York

36 Entertaining (from *Men at Home* series) 1985

Photogravure from mylar drawing, re-worked with etching, aquatint, roulette,
 drypoint, and mezzotint rockers; edition of 60
Image: 79.7 x 52.4 cm (31⅜ x 20⅝ in.)
Sheet: 91.5 x 63.2 cm (36 x 24⅞ in.)
Paper: Arches Cover
Printed by Deli Sacilotto at GRAPHICSTUDIO, University of South Florida.
 Published by GRAPHICSTUDIO, University of South Florida
GRAPHICSTUDIO, University of South Florida
Photo: George Holzer

Consisting of five grissage intaglio prints, Michael Glier's *Men at Home* series examines the anxiety and loneliness of urban life from the single man's viewpoint. In three of the images the man is alone, either performing mundane tasks or else being passively and marginally entertained by watching television. In another image, a man embrances a woman from behind, his head buried in her bosom, ignoring her upturned face. In *Entertaining,* the man is using a blender to make drinks for a faceless woman, his own face anxious and unhappy. The grissage technique enhances the essential emptiness of the scene. Yet Glier animates the image with his quirky, energetic line and his use of patterning, playing off the regularity of the elongated geometric shapes covering the wall against the less regular pattern of the shirt. The tattoo on the host's left forearm complements the icthyological motif of the shirt, making the pattern seem continuous even where it is interrupted by the superimposition of the arm.

KEN GOODMAN
Born New York, New York, 1950; lives New York, New York

37 **Untitled (State II)** 1985

Screenprint; edition of 25
Image and sheet: 63.5 x 50.8 cm (25 x 20 in.)
Paper: Stonehenge
Printed by Donald Sheridan and Robert Bardin at Editions Sheridan Bardin.
 Published by the artist
Lorence • Monk Gallery, New York
Photo: Eric Pollitzer

In the first state of *Untitled,* Ken Goodman's first print, the artist recycled an image of a man staring out a window (from his 1983 painting *Lookout)* by isolating the figure from the context, thus reducing the narrative element. In the second state, the concern with process becomes more evident by the artist's obscuring part of the image with black and silver brush-strokes. Rather than negating the original image, this obfuscation signifies the need for close examination, an imaginative leap in penetrating the overlay and recognizing the cover gestures as a further step in the image-making process.

ROBERT GORDY
Born Jefferson Island, Louisiana, 1933; lives New Orleans, Louisiana

38 **Figure in Landscape** 1985

Monotype; edition unique
Image: 71.1 x 52.1 cm (28 x 20½ in.)
Sheet: 99.7 x 75 cm (39¼ x 27½ in.)
Paper: Fabriano Murillo
Printed and published by the artist in his studio
Arthur Roger Gallery, Louisiana

As the scale of Robert Gordy's work has increased, the subjects in his monotypes have evolved from tightly cropped heads, loosely based on African sculpture, into full figures. The male figure in *Figure in Landscape* is drawn with the economy of line that has always characterized Gordy's work. Gordy places this exaggeratedly proportioned figure in a highly schematized landscape of indeterminate space, in which the proportion of the trees in respect to the figure suggests far distance. The placement of the trees to the left and a line extending from the figure's shoulders to the fir tree at the right encloses the image, intensifying the frontal placement of the figure. The cleanly wiped and undrawn areas balance the muddy colors Gordy uses for this piece.

APRIL GORNIK
Born Cleveland, Ohio, 1953; lives New York, New York

39 **Rolling Clouds** 1985

Monotype; edition unique
Image: 45.8 x 61 cm (18 x 24 in.)
Sheet: 57.2 x 78.8 cm (22½ x 31 in.)
Paper: German Etching
Printed by Sylvia Roth and Susan Mallozzi at Hudson River Editions.
 Co-published by the artist and Hudson River Editions
Edward Thorp Gallery, New York
Photo: Zindman/Fremont

The compositional arrangement of April Gornik's landscapes attests to her concern with such pictorial problems as balance and design. Her work deals not so much with nature itself as with painting nature. There is a schematic quality to the pictorial tensions she creates that calls attention to itself, as if reexamining the conventions of Western landscape painting by parodying those very conventions. In *Rolling Clouds,* an almost overly familiar subject of realist painting, Gornik balances the dark mass of the mountaintops with the equally massive thunderclouds at the top of the composition, effectively dividing the picture plane horizontally into three nearly equal areas. The middle area, the lightest in tonal values, is divided vertically by the narrow cloud at the center of the image. The color is theatrical, injecting the work with a slightly surreal character.

ANTHONY-PETR GÓRNY
Born Buffalo, New York, 1950; lives Philadelphia, Pennsylvania

40 **A Queen's Autumn (a.k.a. A queer fall)** 1985

Lithograph and chine collé; edition to be determined
Image: 36.2 x 24.5 cm (14¼ x 9⅝ in.)
Sheet: 71.1 x 55.9 cm (28 x 22 in.)
Paper: Echizen Unryu collé on the artist's handmade paper
Printed and published by the artist
Dolan/Maxwell Gallery, Pennsylvania

Freely subverting art history by ironic juxtapositions, Anthony-Petr Górny produces political yet highly personal statements in his lithographs. The portrait in *A Queen's Autumn* is Górny's adaptation of a miniature from about 1635, *Catrina d'Austria, Duchessa di Savoia* by the Florentine Giovanna Garzoni. Within the face of this symbol of imperial power, Górny drew an image from *La Fraternité,* a bas-relief celebrating the French Revolution by Jules Dalou (1838–1902), a sculptor who was forced to flee France after the collapse of the Paris Commune in 1871. Over the combined image, the artist drew a spiral that is at once a defacement and a purely autographic mark. The background is a nonobjective field of tusche washes in the style of Helen Frankenthaler's veils of color, with vaguely calligraphic marks at the left. The legend at top and bottom was deliberately not reversed on the stone in order to avoid a too literal reading.

NANCY GRAVES
Born Pittsfield, Massachusetts, 1940; lives New York, New York

41 **Six Frogs** 1985

Screenprint; edition of 66
Image and sheet: 74.9 x 105.4 cm (29½ x 41½ in.)
Paper: Arches 88 Silkscreen
Printed by Hiroshi Kawanishi, Kenjiro Nonaki, and Jon Krawczuk at
 Simca Print Artists, Inc. Published by Simca Print Artists, Inc.
The artist

From the exploding center of *Six Frogs,* the varied elements of the image move about the edges in a radial pattern, creating the impression of frenzied revolution. Sculpted classical heads, a mosaic of a pheasant, and frogs are all of equal pictorial value. More gestural biomorphic forms occupy the frontal plane. The background color is a rich metalic bronze with the explosive center lavender overlaid with warm brown and red. Iridescent, fluorescent, and mat colors create a precariously balanced tension. The title is playful, as not all six frogs are completely visible. Everything is printed just slightly off-register to add to the visual conundrum.

MICHAEL HAFFTKA
Born New York, New York, 1953; lives Brooklyn, New York

42 **Undertones** 1985

Portfolio of four prints, incorporating etching, monotype, and other techniques; edition of 6

#127: hard-ground etching, spray-paint aquatint, and monotype; *#128:* hard-ground etching and monotype; *#129:* hard- and soft-ground etching, sugar lift, spray-paint aquatint, and monotype; *#130:* hard-ground etching and monotype

Each image: 30.5 x 22.9 cm (12 x 9 in.)
Each sheet: 47 x 38.1 cm (18½ x 15 in.)
Paper: Fabriano Tiepolo
Printed by the artist and Mark Baron at Mark Baron. Published by Mark Baron
Both sets: *Mark Baron, New York*

The image illustrated here is *#130.*

The title of Michael Hafftka's portfolio *Undertones* indicates his concern with psychological states conveyed by nightmarish imagery. With no formal training, Hafftka began drawing in 1974 and soon moved on to painting. He did not attend art school but educated himself by studying the work, often in reproduction, of artists who interested him: Francis Bacon, the early paintings and the late etchings of Picasso, early Matisse and Klee, and Dubuffet. Much of his imagery is generated by dreams, although he also works from models. In *Undertones,* as in the rest of his work, his intention is never to portray physical likenesses but to capture psychological reality. The agitated energy of his etched line in this portfolio of prints is enhanced by the monotype application of strong colors, especially the blood red of the first and last plates.

RICHARD HAMBLETON
Born Vancouver, British Columbia, 195?; lives New York, New York

43 **Figure (Monsoon)** 1985

Screenprint with hand-coloring; edition of 38
Image: 185.5 x 76.2 cm (73 x 30 in.)
Sheet: 195.6 x 86.4 cm (77 x 34 in.)
Paper: Stonehenge
Printed by Alexander Heinrici at Studio Heinrici. Published by
Civilian Warfare Graphics
Civilian Warfare, New York

Richard Hambleton accentuates the exaggerated verticality of *Figure (Monsoon)* with a vertical band of black near the left edge of the image, establishing a frontal plane and, by quoting Barnett Newman's "zip," calling attention to his own relation to the Abstract Expressionists with their overall composition. The flat human torso, executed in a loose, drippy style, recalls his pre-1982 street paintings of flat black figures. It concentrates the mass in the lower foreground, just behind the skin of the image, further defining the verticality of the format and establishing a point of reference for the deep, undefined space of the background. Hambleton flicked seven shades of acrylic wash across the sheet in a diagonal stripe pattern, establishing the image of rain on a window in the extreme frontal plane.

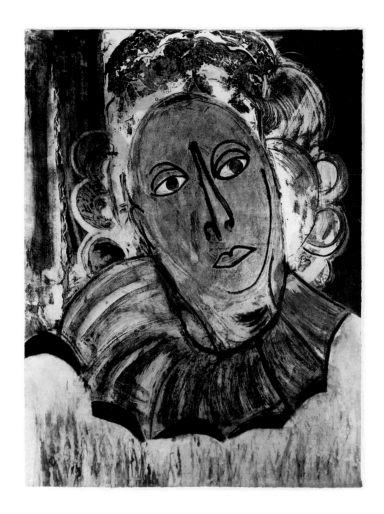

GRACE HARTIGAN
Born Newark, New Jersey, 1922; lives Baltimore, Maryland

44 **Elizabeth Etched** 1985

Ink ground, aquatint, and spit bite; edition of 50
Image and sheet: 102.9 x 77.5 cm (40½ x 30½ in.)
Paper: German Etching
Printed by Roberto De Lamonica, Sylvia Roth, Joseph Dieboll,
 Susan Mallozzi, and Steven Szczepanek at Hudson River Editions.
 Published by Gruenebaum Gallery
Gruenebaum Gallery, New York
Photo: Eric Pollitzer

Late in her career, Grace Hartigan has moved from nonrepresentation into figurative imagery.
Elizabeth Etched is based on a painting of Elizabeth I from a series of 1983–84 works,
Great Queens and Empresses, in which the subjects were more generic women defined by the
trappings of role and position than specific portraits. In this series, Hartigan based her figures
on de Kooning's early 1940s paintings of women, especially *Queen of Hearts,* ca. 1943,
with their heavy-lidded eyes and vacant expressions. Particularly in the neck and head area
of *Elizabeth Etched,* line cuts through tone rather than containing it. By etching the aquatint
in the spit bite technique, Hartigan achieves a very brushlike, painterly style in the nonlinear
passages.

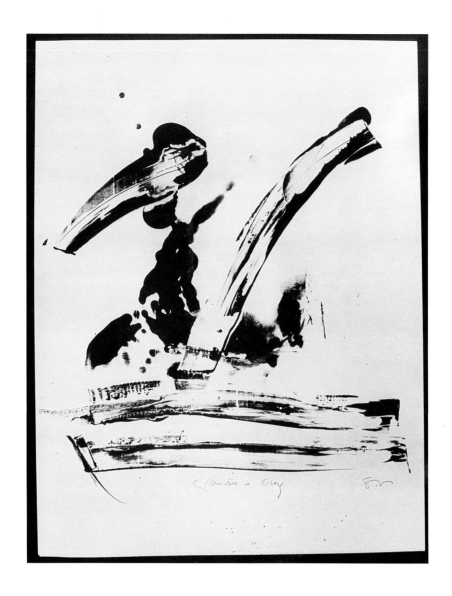

STEPHEN HAZEL
Born Goshen, Indiana, 1934; lives Seattle, Washington

45 Structure in Glass 1985

Lithograph; edition of 35
Image and sheet: 116.8 x 88.9 cm (46 x 35 in.)
Paper: Manadnock
Printed by Charles Matson at Winn Press. Published by the artist
The artist

Structure in Glass is one of a series of lithographs (the other two are *Structure in Steel* and *Structure in Stone)* in which Stephen Hazel deals not only with the traditional sculptural concern of the three-dimensional figure in space but also with how the properties of these various materials can be rendered in black on a white two-dimensional surface. With the use of tusche washes, Hazel captures the transparency of the glass structure as well as indicating the effect of light passing through glass. The image itself is elongated and elegant, even somewhat fragile, as befits the material depicted.

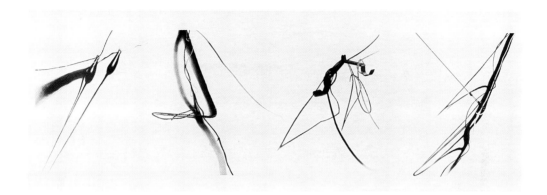

NONA HERSHEY
Born New York, New York, 1946; lives Rome, Italy

46 **Suite** 1984

Aquatint; edition of 30
Three plates: *(left and right)* 48.9 x 38.9 cm (19¼ x 15⅝ in.),
 (center) 48.9 x 79.4 cm (19¼ x 31¼ in.)
Sheet: 69.2 x 196.9 cm (27¼ x 77½ in.)
Paper: Magnani Pescia
Printed by Giancarlo Iacomucci and Angelo Gabbanini at Stamperia 3K.
 Published by the artist and Il Ponte Gallery
Dolan/Maxwell Gallery, Pennsylvania

Suite is the most open, spare, and ambitious of Nona Hershey's aquatints to date. Dealing, as always, with the subtle patterning of light and shadows, she has increased her usual scale immensely in this print and treated a linear network in exterior light rather than the effects of an outside light source on interior space. The image is a nexus of electrical wires, their linearity broken at conjunctions by the transformers of varied shapes. Hershey, by isolating the image, endows what is generally considered an eyesore with a rhythmic grace. The title connotes both a series of related or conjoined objects and a suite in musical terms, as the image suggests musical notation.

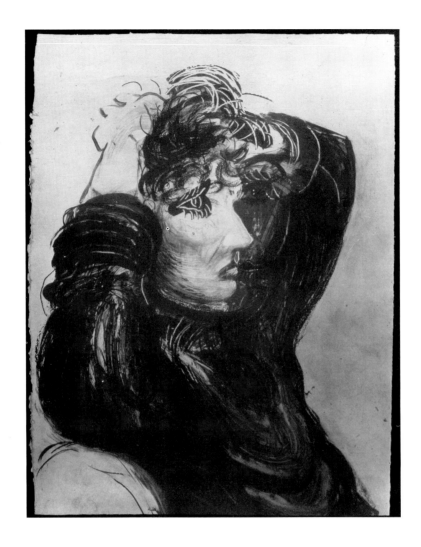

DAVID HOCKNEY
Born Bradford, England, 1937; lives Los Angeles, California

47 **Red Celia** 1985

Lithograph; edition of 82
Sheet: 76.3 x 54.6 cm (30 x 21½ in.)
Paper: HMP handmade paper
Printed by Kenneth Tyler, Roger Campbell, and Lee Funderburg at
 Tyler Graphics, Ltd. Published by Tyler Graphics, Ltd.
Tyler Graphics, Ltd., New York
Photo: ©Steven Sloman

The ongoing series of prints that David Hockney is producing at Tyler Graphics, Ltd. is the most sustained and ambitious prolonged collaboration that this workshop has ever undertaken. While most of the prints are ambitious in imagery and scale, *Red Celia* is intimate in both size and mood. As in most of his post-photomontage work that abandons one-point perspective, Hockney uses dual perspectives here. In this print, the artist uses certain techniques traditionally associated with monotypes—the clean wipe at the end of the subject's nose and, especially, the scratching of the details of the eye from the dark field. The painterly mass of the red sweater is balanced by the unmodeled line drawing of the hand and chair back.

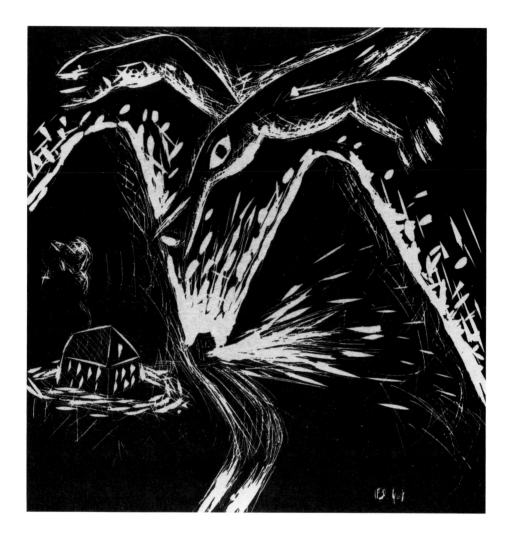

DAVID HUMPHREY
Born Augsburg, West Germany, 1955; lives New York, New York

48 **Nocturne** 1984

Linoleum cut; edition of 15
Image: 25.4 x 25.4 cm (10 x 10 in.)
Sheet: 45.3 x 45.3 cm (18 x 18 in.)
Paper: Japan Sumi
Printed by Paul Marcus at Paul Marcus Studio. Published by the artist
*The Brooklyn Museum 85.42, Louis Comfort Tiffany Foundation
 grant purchase*

If a nocturne is a musical composition of a dreamy or pensive character, David Humphrey's *Nocturne* is a composition of a nightmarish character. A train, orgasmically spewing forth light, races between two volcano- (or breast-) shaped mountains. The house in the foreground is encircled by a ring of light from no discernible source. Above this, a predatory bird, its wings echoing the shapes of the mountains, soars downward, its beak open for the kill. The bird is of monstrous proportions. Humphrey makes most of his marks by gouging into the block in a manner reminiscent of Gauguin's proto-expressionist gouged woodcuts. Even the windows of the house are gouged with downward thrusts, like tears or drops of blood.

BILL JENSEN
Born Minneapolis, Minnesota, 1945; lives New York, New York

49 **Studio** 1983–84

Etching and aquatint; edition of 30
Image: 17.4 x 12.4 cm (6⅞ x 4⅞ in.)
Sheet: 50.5 x 38.6 cm (19⅞ x 15¼ in.)
Paper: handmade
Printed by John Lund at Universal Limited Art Editions, Inc.
 Published by Universal Limited Art Editions, Inc.
The Brooklyn Museum 85.59, Louis Comfort Tifffany Foundation
 grant purchase

While the large teardrop shape seems frozen in centrifugal motion, the quarter-moon shape describes a centripetal path in Bill Jensen's *Studio,* each emanating from an imagined rotary source. The convergence of these two forms is balanced by the force with which they seem to break out from the confining space of the picture plane. Jensen's biomorphic shapes have their antecedents in the work of such first-generation American modernists as Marsden Hartley and Arthur Dove, with whom he shares a particular reverence for nature in his use of abstraction. *Studio* is Jensen's first print as a mature artist. By constantly reworking the plate over a period of more than a year, he developed such a variety of marks that the print seems to bespeak years of intaglio experience. As in his paintings, the scale is intimate and the image compressed and intense.

JASPER JOHNS
Born Augusta, Georgia, 1930; lives Stony Point, New York

50 **Ventriloquist** 1985

Lithograph; edition of 67
Image and sheet: 106.8 x 71.1 cm (42 x 28 in.)
Paper: J. Green
Printed by Keith Brintzenhofe at Universal Limited Art Editions, Inc.
 Published by Universal Limited Art Editions, Inc.
*The Museum of Fine Arts, Houston. Museum purchase with funds provided
 by Mr. and Mrs. Bryan Trammel, Jr.*
Photo: A. Mewbourn

In *Ventriloquist,* Jasper Johns isolates a detail from a 1983 painting of the same title, enhancing the mystery of the image by removing it from the larger context. The overall composition is an initial "I" or Roman numeral one, created by the semi-trompe l'oeil overlay of two extreme edges of Johns's double flag drawings on either side of the print. Whereas in the painting the flags are different colors, they are the same color in the print, heightening the implied circular continuum. The three pieces of George Ohr pottery are from Johns's own collection, a vaquely autobiographical allusion. Johns stresses the two-dimensional representation of three-dimensional objects by overlapping the flag drawings with the ceramic vessels at the top and bottom of the print. The subdued richness of color re-creates the textured semi-transparency of Johns's encaustic paintings.

ROBERTO JUAREZ
Born Chicago, Illinois, 1952; lives New York, New York

51 **Arrowroot** 1985

Woodcut; edition of 40
Image: 115.5 x 91.4 cm (45½ x 36 in.)
Sheet: 124.5 x 96.5 cm (49 x 38 in.)
Paper: Kozo Fusuma
Printed by Chip Elwell, Andrew Bovell, and Earl E. Bovell.
 Published by the artist, Chip Elwell, and Scholl Graphics
Chip Elwell, New York

By framing *Arrowroot* with an elaborate border, Roberto Juarez simultaneously enhances and undermines the decorative aspects of the print. While decorative in itself, the border crops the image and, by minicking a traditional frame, calls attention to the print as object, a two-dimensional charting of what in nature would be a three-dimensional object. The sensuous curves of the branches and the delicacy of the blossoms are balanced by the large, pointed leaves, which seem menacing in juxtaposition. Juarez uses a shallow, indeterminate space, again stressing the flatness of the picture plane. The light-absorbing opacity of the dark, earthy color of the leaves contrasts with the light-reflective qualities of the opaque white and the silver of the background.

DENNIS KARDON
Born Des Moines, Iowa, 1950; lives New York, New York

52 **Charlotte's Gaze** 1985

Lithograph and woodcut; edition of 38
Image and sheet: 62.9 x 69 cm (24¾ x 27⅛ in.)
Paper: Gasen Natural
Printed by David Keister and David Calkins at Echo Press.
 Published by Echo Press
Echo Press, Indiana
Photo: David Keister

While continuing to explore the assassination of the French Revolutionary leader Jean-Paul Marat while in his bath by Charlotte Corday, Dennis Kardon has changed both his style and his medium. The previous flat semi-abstraction that relied heavily on patterning has been replaced by "warts and all" realism, and the medium is no longer woodcut but lithography, with woodcut added to the hair, turban, and water for its textural properties. Photoplates of the woodgrain texture were then printed to further enhance the texture. In this image, the viewer sees the unsuspecting Marat, radically cropped so that his back assumes monumental proportion, from Corday's perspective as her eyes focus on her target.

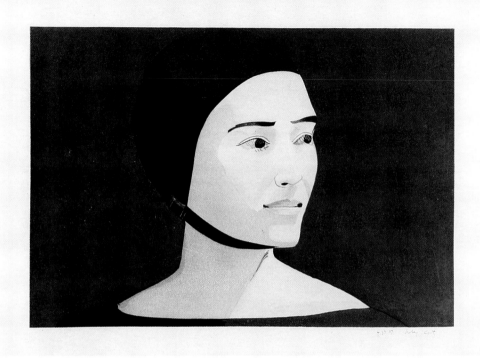

ALEX KATZ
Born New York, New York, 1927; lives New York, New York

53 **The Green Cap** 1985

Woodblock print; edition of 200
Image: 31.2 x 45.4 cm (12¼ x 17⅞ in.)
Sheet: 44.5 x 61 cm (17½ x 24 in.)
Paper: Tosa Kozo
Printed by Tadashi Toda in Kyoto, Japan. Published by Crown Point Press
Crown Point Press, California and New York

Bathed in an uninflected even wash of light that, by eliminating shadows, flattens contours, the figures in Alex Katz's portraits are generalized but never lifeless. By allowing intuition as well as visual notation to inform his imagery, Katz creates pictorial representations that operate as synthetic symbols on a number of levels, so that the work is instantly readable yet contains multiple nuances. The figure in *The Green Cap* is at once contemporary and timeless, a specific person and an icon. Katz, who always tries to push any medium he works in to its limits, here used the Japanese technique of layering transparent waterbased inks to create a a seamless modulation of tone. The horizontal format of what would normally be a vertical image and the slight cropping of the top of the head endow the image with expansiveness and immediacy.

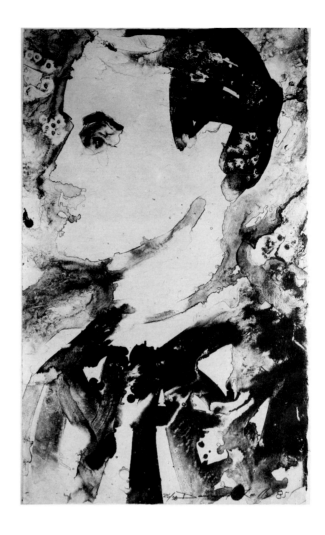

DANIEL KELLY
Born Idaho Falls, Idaho, 1947; lives Kyoto, Japan, and New York, New York

54 **Blaine** 1985

Lithograph; edition of 38
Image and sheet: 76.9 x 47 cm (30¼ x 18½ in.)
Paper: Washi
Printed by Segoshi Yoshimitsu at Edition Works, Tokyo. Published by the artist
Mary Ryan Gallery, New York

Daniel Kelly originally went to Japan to study traditional woodblock techniques with the master printers who still employ nineteenth-century *ukiyo-e* techniques. His interest has lately turned more toward lithography, although the Oriental influence is still strongly evident. *Blaine* is a portrait of the artist's father, sparingly rendered in wide, expressive strokes of tusche wash that, in their economy, emulate Oriental brush paintings and calligraphy. The exaggerated vertical format and the delicacy of the paper echo that of a scroll. There is an Occidental brashness to the work, however, so that *Blaine* contains elements of both Eastern and Western traditions.

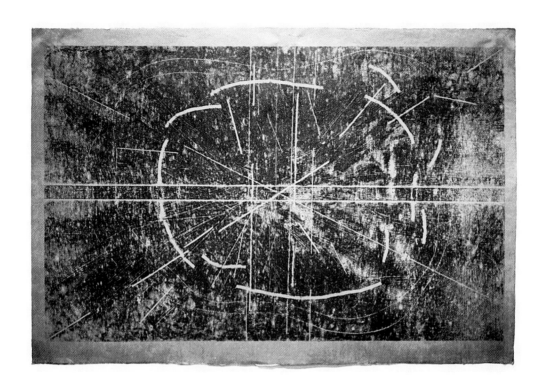

MARIO KON
Born Buenos Aires, Argentina, 1944; lives Boston, Massachusetts

55 **Untitled** 1985

Monotype; edition unique
Image and sheet: 63.5 x 96.5 cm (25 x 38 in.)
Paper: rice paper
Printed and published by the artist
Nielsen Gallery, Massachusetts

Mario Kon's untitled dark-field monotype relates, in two-dimensional terms, to the delicate tracery of his wire sculptures. In this form of monotype, the artist rolls ink over the entire surface of the plate, then scratches or rubs out areas of light tonalities. Scratching through the inked field enables the artist to make finer lines than would be possible in an additive monotype. Kon uses two such horizontal lines to bisect the image into upper and lower halves, stressing the relation between the segments of the broken oval form that is the central image. He thus emphasizes the dialogue between the two segments in which the lines complement but do not mirror each other.

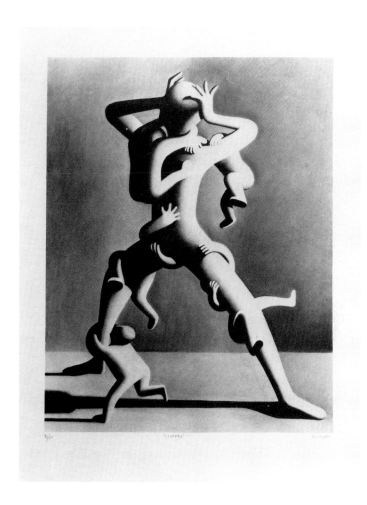

MARK KOSTABI
Born Whittier, California, 1960; lives New York, New York

56 **Climbing** 1985

Screenprint; edition of 100
Image: 54.6 x 43.2 cm (23⅛ x 17¾ in.)
Sheet: 76.3 x 55.8 cm (30½ x 22 in.)
Paper: Stonehenge
Printed by Donald Sheridan and Robert Bardin at Editions Sheridan-Bardin.
 Published by the artist
Lorence • Monk Gallery, New York
Photo: Eric Pollitzer

Climbing is an out-and-out reproductive print, one which twenty years ago would have been dismissed as not being "original" according to the definition of the Print Council of America. Kostabi reproduced a half-tone photograph of his 1982 painting of the same title by having it transferred to screens and then printed. Photomechanical reproduction has become so much a part of the current visual experience, however, that the commercial look of the print is perfectly matched to the aesthetic. Five faceless protohuman figures climb up the limbs and body of a larger figure, as if scrambling up a tree. The image can be traced to a decided influence of science-fiction comics, so that the commercially printed look of the screenprint emphasizes the source, much as the Ben-Day dots that Lichtenstein used in his early screenprints quote the cheap printing of comic books.

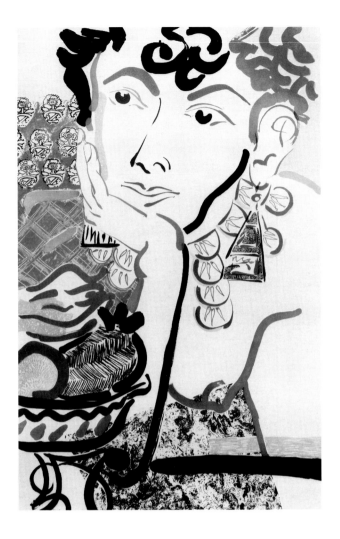

ROBERT KUSHNER
Born Pasadena, California, 1949; lives New York, New York

57 **Bibelot** 1985

Aquatint; edition of 10
Image and sheet: 155.6 x 100.6 cm (61¼ x 39⅝ in.)
Paper: Somerset
Printed by Jeryl Parker, Brenda Zlamany, Joanne Howard, and Gregory Burnet
 at Jeryl Parker Editions. Published by Crown Point Press
Crown Point Press, California and New York
Photo: Bill Jacobson

For Robert Kushner, time spent in India and the Middle East, where almost no distinction is made between fine art and decoration, and his often-noted affinity with Matisse have been major influences in the development of his aesthetic. Pattern never overwhelms his concern with the representational side of his work in the depiction of botanical form or, more often, the figure; each element informs the other. In *Bibelot,* the unprinted areas assume equal weight with the patterned areas; the flat whiteness of the paper is treated as a positive compositional and tonal element. The print was done using only aquatint, even for the fine lines of the chevron patterns in the fruit in the lower left foreground. The linear elements have a marvelously rich texture as well as a remarkable variety of weight and value.

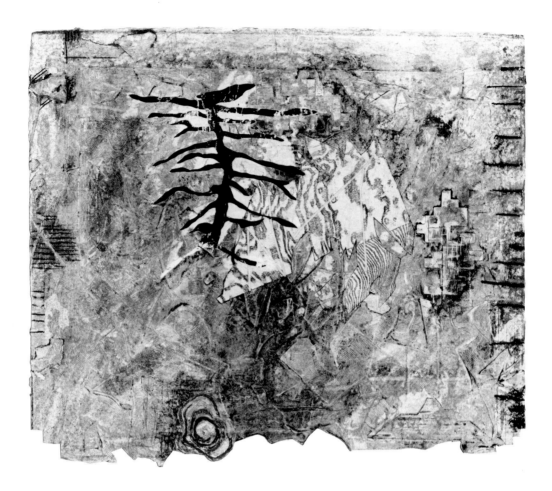

TERENCE LA NOUE
Born Hammond, Indiana, 1941; lives New York, New York

58 S.F. Monterey Series #8 1985

Monoprint from collograph plates, collage, and hand-coloring with color pencil
 and pastel; edition unique
Image and sheet: 64.7 x 75.5 cm (25½ x 29¾ in.)
Paper: Experimental Workshop handmade paper
Printed by Wil Foo and John Stemmer at Experimental Workshop.
 Published by Experimental Workshop
Private collection, Illinois, courtesy of Experimental Workshop, California
Photo: Diana Crane

In his *Monterey Series,* Terence La Noue has been able to approximate in graphic medium
the built-up bas-relief textures of his paintings. By using collotype plates, a process in which
elements are affixed to a cardboard plate that is then relief inked and printed, he conveys
both shapes and textures. The jagged shape of the bottom of the paper, made specifically for
this project, translates the irregularly shaped supports that are an essential component of La
Noue's work. As the title suggests, the image is an abstract landscape in which self-contained
shapes of varied surface textures create a rhythmic play of tenuously balanced tensions.
The soft pastel shades of the predominant colors establish further tension between aggressive
shapes and muted tonalities.

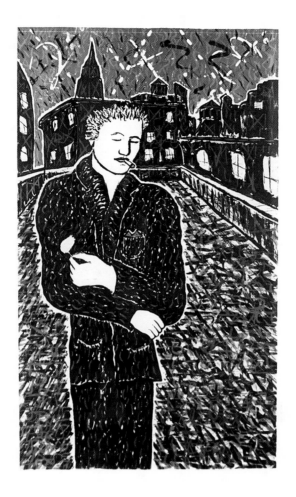

KEVIN LARMEE

Born Ridgefield Park, New Jersey, 1946; lives New York, New York

59 **Cigarette** 1985

Lithograph; edition of 75
Image: 103.9 x 62.9 cm (40⅞ x 24¾ in.)
Sheet: 122 x 81 cm (48 x 31⅞ in.)
Paper: Rives BFK
Printed by Holly Sears and Michael Richards at the Printmaking Workshop,
 New York. Published by Avenue B Gallery
Avenue B Gallery, New York

For centuries, one of the main functions of printmaking has been to disseminate the work of painters and sculptors to a wider audience than could ever see their unique work. For Kevin Larmee, however, making prints seems to be a step in a conservative, more traditional direction. Previously, Larmee had made his paintings accessible by working on exterior surfaces throughout Manhattan, most recently in a series depicting rooftop swimming pools. In *Cigarette,* the composition is only the slightest variation on that of the pool paintings. The single figure dominates the extreme foreground while a midground of roof extends behind it, surrounded by the tops of buildings. The autographic marks in the sky, a looser rendition of the red, black, and blue marks that enliven the surface of the roof, suggest celebratory fireworks.

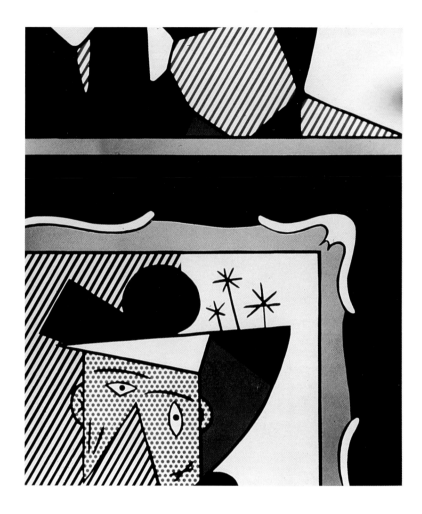

ROY LICHTENSTEIN
Born New York, New York, 1923; lives Southampton, New York

60　**Two Paintings**　1984

Woodcut, lithograph, screenprint, and collage; edition of 60
Image: 109.2 x 91.1 cm (43 x 35⅞ in.)
Sheet: 116.2 x 99.1 cm (45¾ x 39 in.)
Paper: Arches 88
Printed by Anthony Zepeda, James Reid, Kevin Kennedy, Krystine Graziano,
　Richard Hammond, and Ron McPherson at Gemini G.E.L.
　Published by Gemini G.E.L.
Gemini G.E.L., California and New York

While working with the vocabulary of Ben-Day dots and closely spaced parallel straight lines
that has long characterized his work, one of Roy Lichtenstein's major interests since the late
1960s has been an examination of great artworks of the past in terms of contemporary tech-
niques of mass reproduction. In the *Cathedrals* and *Haystacks* series, he used a pattern of
regular dots as Monet had used impressionist brushwork to indicate effects of light. In *Two
Paintings,* Lichtenstein juxtaposes details of Picasso and Jasper Johns images in which cor-
responding shapes (such as the triangles) are used in entirely different pictorial systems.
Lichtenstein's characteristic lines simultaneously conjoin and disjoin the images, as well as
stressing the objectness of the paintings, as does the frame on the "Picasso."

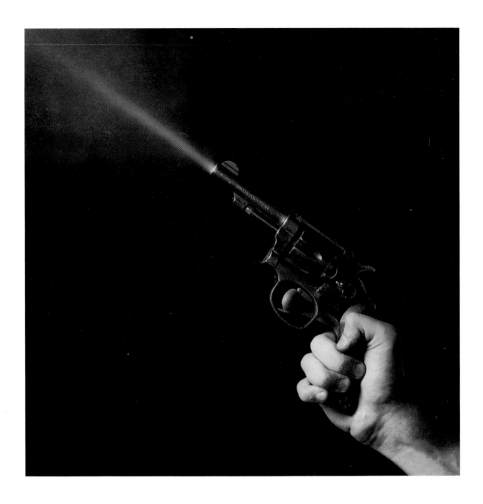

ROBERT MAPPLETHORPE
Born New York, New York, 1946; lives New York, New York

61 **A Season in Hell** 1986
(A new translation of Rimbaud by Paul Schmidt)
Portfolio of eight photogravures on chine collé; edition of 40
Each image: 11.5 x 11.5 cm (4½ x 4½ in.)
Each sheet: 26.7 x 36.8 cm (10½ x 14½ in.)
Paper: Sekishu Torinoko Gampi collé on Cartière
 Enrico Magnani handmade paper
Plates made by Jon Goodman at Jon Goodman Photogravure. Printed by
 Robert Townsend at R.E. Townsend. Published by Limited Editions Club
Two sets: *Limited Editions Club, New York*
The image illustrated here is *Gun Blast.*

Like most "fine" printmaking processes, photogravure was originally developed for commer-
cial reproduction. Artists later realized that it possessed unique tonal characteristics that, when
adapted to photographically generated imagery, achieved a richness of surface obtainable in
no other way and was thus a suitable vehicle for producing multiple images that qualified
as art. The gravure process therefore links Robert Mapplethorpe's photographs with print-
making. The eight images in this *livre d'artiste* do not so much illustrate Rimbaud's poem as
they evoke the mystical, nocturnal melancholy that characterizes the work. Mapplethorpe's
images provoke an emotionally layered response in harmony with the text.

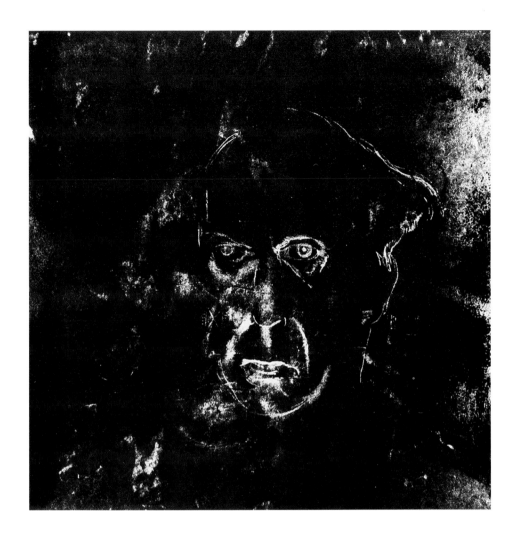

MICHAEL MAZUR
Born New York, New York, 1935; lives Cambridge, Massachusetts

62 **Untitled 12/31/84** 1984

Traced monotype; edition unique
Image: 45.7 x 45.7 cm (18 x 18 in.)
Sheet: 61 x 54.6 cm (24 x 21½ in.)
Paper: Kozo
Printed and published by the artist
Barbara Krakow Gallery, Massachusetts

No artist has worked consistently in the medium of the traced monotype since Gauguin developed the technique and produced a steady output of work between 1899 and 1903. Having used the standard forms of monotype as a primary medium for many years, Mazur recently decided to try Gauguin's technique, intriqued by its simplicity and by the possibilites it presented for purity of drawing. On reaching his fiftieth birthday, he began a self-examination through a series of traced monotype self-portraits in which likeness was only a point of departure. *Untitled 12/31/84* bears a startling resemblance to Camille Pissarro's etched self-portrait of 1890 in its straightforward pose, the beret, and the intensity of the eyes. Mazur's self-portrait, however, with its allover dark field, has a more brooding type of intensity than Pissarro's.

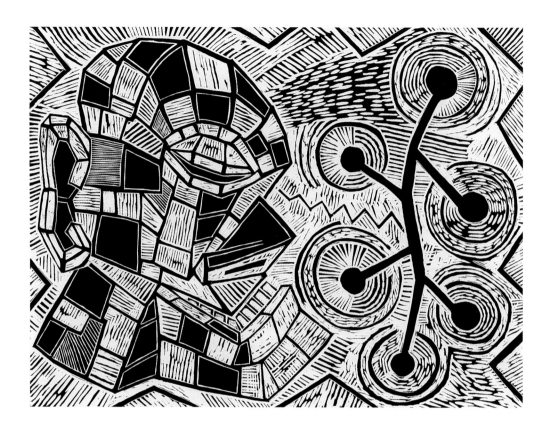

RICHARD MOCK
Born Long Beach, California, 1944; lives Brooklyn, New York

63 **Racing Beauty** 1985

Woodcut; edition of 45
Image: 59.7 x 80 cm (23½ x 31½ in.)
Sheet: 91.4 x 110.5 cm (36 x 43½ in.)
Paper: Suzuki
Printed by Chip Elwell at Chip Elwell. Published by Perma Press
Brooke Alexander, New York
Photo: Ivan Dalla Tana

With a half-respectful, half-irreverent quotation of Cubism, Richard Mock breaks the robot-like head at the left of *Racing Beauty* into geometric planes and straight linear markings. This rigidly angular treatment adds a comic ferocity to the science-fiction aspect of the head. The title refers to the figure at the right, a sculpture with a linear framework and spinning circles at the end of its armatures. Compared to the massive solidity of the head, the sculptural figure is graceful and delicate, its spinning circles moving as if in a dance. While the head is exaggeratedly masculine, the sculpture, with its circles and curved lines, is decidedly feminine. The title hints that Mock is predicting a 21st-century version of Beauty and the Beast.

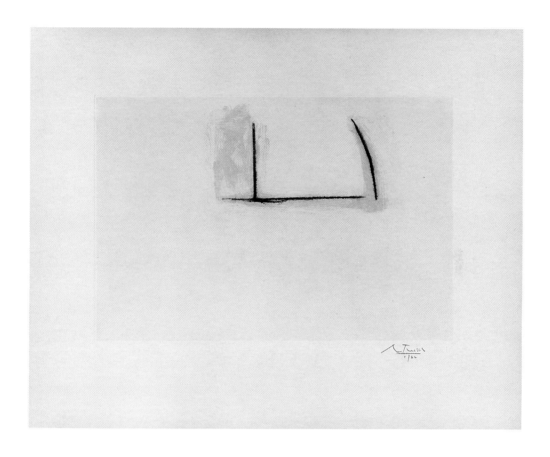

ROBERT MOTHERWELL
Born Aberdeen, Washington, 1915; lives Greenwich, Connecticut

64 **Naples Yellow Open** 1984

Etching and aquatint; edition of 62
Sheet: 49.2 x 63.5 cm (19⅜ x 25 in.)
Paper: German Etching
Printed by Catherine Mosely at the artists' studio. Published by
 Tyler Graphics, Ltd.
Tyler Graphics, Ltd., New York
Photo: ©Steven Sloman

In *Naples Yellow Open,* the pale yellow rectangle interacts with the white field of the paper not only as image and border but also as a color relation study in the mode of Josef Albers. The sheet is transformed from a negative support into a positive compositional and tonal value. The lines describe an open form irregular in shape. At the left, the horizontal line exceeds the right angle but, at the right, it does not quite join the curved line. Motherwell's concern is the property and placement of line rather than the enclosure of form. Pale gray aquatint, like a transparent wash, underlies the linear elements, establishing an elegant counterpoint between line and tone.

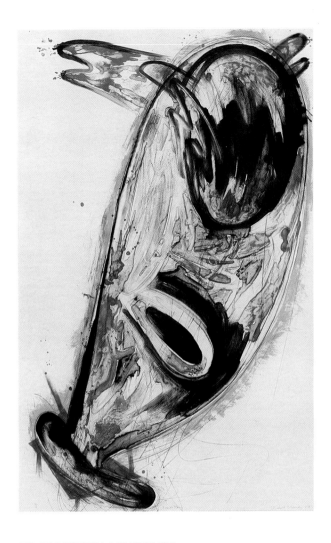

ELIZABETH MURRAY
Born Chicago, Illinois, 1940; lives New York, New York

65　**Inside Story**　1984

Lithograph with hand-coloring; edition of 14
Image and sheet: 148 x 92 cm (58¼ x 36¼ in.)
Paper: Arches 350 Gr.
Printed by Maurice Sanchez, James Miller, and John Volney at Derrière
　L'Etoile Studios. Co-published by Brooke Alexander and Paula Cooper
*The Brooklyn Museum　85.32.1, Louis Comfort Tiffany Foundation
　grant purchase*

As in her shaped canvases, the most powerful element of Elizabeth Murray's *Inside Story* is dynamic thrust, an upward explosion that, in this case, can just barely be contained by the traditional rectangle of the lithographic plate. Starting with one of the most homely images imaginable, a coffee cup, Murray tortures the shape into a torpedo-like form, an instrument of power and destruction. The coffee sloshes over the rim from the force of the upward thrust. Murray negates a too-literal reading of the image by her coloration — soft blues, greens, and pinkish lavender — and their watercolor-like transparency, achieved by painting on the lithographic plates with water-based tusche washes. Hand-coloring is used only to strengthen the black loops at the top of the image.

FRANCES MYERS
Born Racine, Wisconsin, 1936; lives Madison, Wisconsin

66 **Martyrdom** 1984

> Linoleum cut and stencil; edition of 50
> Image and sheet: 50.8 x 38.1 cm (20 x 15 in.)
> Paper: Arches Cover
> Printed and published by the artist
> *Lorence • Monk Gallery, New York*
> Photo: Eric Pollitzer

Over the last three years, Frances Myers has effected a radical change in both the imagery and the medium of her prints. Earlier, she had made aquatints based on 20th-century American architecture, cool, elegant prints that were somewhat distancing and formal. With the shift to more personal figurative imagery, she changed her matrix to the linoleum block, with its more expressionistic possibilites. *Martyrdom* is one of a series of prints dealing with the comic-book character Superwoman. The expressively cut figure in this image is flanked by two Art Deco columns, a reference to her earlier work.

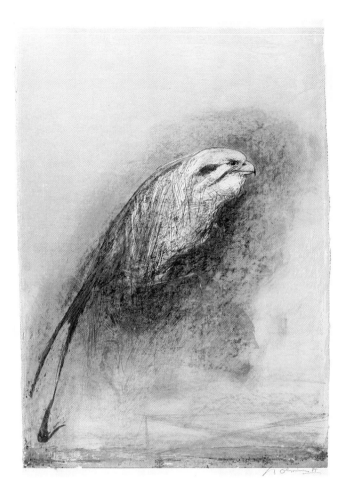

NATHAN OLIVEIRA

Born Oakland, California, 1928; lives Palo Alto, California

67 **Kestrel Series #10** 1985

Woodcut, hand-colored with pastel and graphite pencil; edition unique
Image: 101.6 x 75 cm (40 x 29½ in.)
Sheet: 122 x 75 cm (48 x 29½ in.)
Paper: Seiko-sen
Printed by Wil Foo, John Stemmer, and Andrew Saftel, who also cut the
 blocks under the artist's supervision, at Experimental Workshop.
 Published by Experimental Workshop
Experimental Workshop, California
Photo: Diana Crane

From the imaginary archeological sites that have been the subject of most of his recent work in monotype, Nathan Oliveira has reverted to another recurrent image, the kestrel (a small falcon), for his recent series of hand-colored woodcuts. Oliveira isolates the bird in indeterminate, luminous space in a perched position. From the clearly detailed head, the treatment of the body becomes more generalized, an irregular network of lines over modulated areas of tone. The tail is even more schematic, rendered in two sweeping, calligraphic strokes. Margins and a base line define the horizontal boundaries of the image, whereas printing to the vertical edges implies an interrupted panorama. The scroll-like format is in keeping with the reference to Oriental subject matter and stylized treatment of the tail feathers.

JOHN OVERTON
Born Detroit, Michigan, 1948; lives Vashon, Washington

68 **Blue Zone** 1983

Soft-ground etching, reief and intaglio printed; edition of 15
Image: 30.5 x 25.4 cm (12 x 10 in.)
Sheet: 50.8 x 40.6 cm (20 x 16 in.)
Paper: Twinrocker White Feather
Printed and published by the artist
Greg Kucera Gallery, Washington

After working in prints for many years as his primary medium, John Overton stopped printing altogether for more than a year to concentrate on sculpture. Now making prints only occasionally, Overton's concerns in two-dimensional work have become more spatial, as sculptural concerns have come to inform the work. In *Blue Zone,* a non-geometric mid-blue shape emerges tonally from a field of lighter blue. The blues form one deeply recessed plane. Orange shapes and lines — some indentifiable as sailboats on water, others more calligraphic — occupy the frontal plane. Overton's concerns are formal, his primary concern here being the frontality of the orange juxtaposed against the recessiveness of the blues.

ROBERT ANDREW PARKER
Born Norfolk, Virginia, 1927; lives West Cornall, Connecticut

69 Chester Johnson and Myself, Mombasa–Nairobi 1984

Etching and aquatint with hand-coloring; edition of 15
Image: 12.1 x 16.9 cm (4¾ x 6⅝ in.)
Sheet: 26.7 x 33 cm (10½ x 13 in.)
Paper: Lena Gravure
Printed by Anthony Kirk at Eldindean Press, New York.
 Published by Eldindean Press
Eldindean Press, New York

Robert Andrew Parker's intaglio technique is to start by breaking the image into large areas of aquatint, varying from smooth to very granular, upon which he superimposes etched lines to indicate detail. Unlike most intaglio prints in which line encloses and informs tone, Parker composes with tone, using line to draw within tone. The imagery in his prints is sometimes autobiographical and usually evokes a response that, without his wit, would be nostalgic, like stills from a 1940s film. In *Chester Johnson and Myself, Mombasa–Nairobi,* he subverts a typical tourist-snapshot image with patterns of light and shadow that have equal pictorial weight as nonobjective imagery. The window at the right actually frames a discrete image that alludes to Richard Diebenkorn's *Ocean Park* abstract landscape paintings.

CLAYTON PATTERSON
Born Calgary, Alberta, Canada, 1948; lives New York, New York

70 **Black Beauty** 1984

Woodcut with watercolor and pastel; edition of 15
Image and sheet: 116.6 x 93.8 cm (45⅞ x 36⅞ in.)
Paper: Suzuki
Proofed by Chip Elwell. Editioned by Alex Kessler at Chip Elwell.
 Published by Diane Villani Editions
*The Brooklyn Museum 85.60.3, Louis Comfort Tiffany Foundation
 grant purchase*

Clayton Patterson moves freely between sculpture and printmaking, each medium often the
point of departure for the other. *Black Beauty* has as its central image a typical Patterson
sculpture — generally an elongated case on legs that he paints, collages, carves, and fills
with found objects. The case floats atop a demon-filled sea, backed by mountains that refer
to Japanese landscape prints. The sky too is filled with floating figures and graffiti. All this
is bordered by a frame that, in conspicuous restraint, uses the grain of the wood as its only
patterning. This image was printed in black from one block. Patterson then hand-colored each
impression differently with watercolor and pastel.

PHILIP PEARLSTEIN
Born Pittsburgh, Pennsylvania, 1924; lives New York, New York

71 **Models with Mirror** 1983–85

Etching, aquatint, and roulette; edition of 60
Image and sheet: 90.2 x 135.9 cm (35½ x 53½ in.)
Paper: Saunder's hot press
Printed by Nancy Brokopp, Gregory Burnet, Susan Steinbrock, and
 Catherine Tirr at Condeso and Brokopp Studios. Co-published by
 GRAPHICSTUDIO, University of South Florida and 724 Prints, Inc.
724 Prints, Inc., New York

In *Models with Mirror,* Philip Pearlstein recomposes the familiar elements of his mature style: the models seen from unsual angles that stress foreshortening; reflections in mirrors that, because of their placement, reveal additional views of the models; woodgrain textures and Native American rugs. Yet Pearlstein always adds elements of surprise so that his work never seems repetitious. In this case, the wood grain of the bench emerging through the worn green paint is rendered with striking realism, in sharp contrast to the seemingly arbitrary patterns of the studio lights on the models' flesh. The diagonal placement of the rug and the bench thrusts the image out into the viewer's space. The combining of red and green, so often a cliché, is here used with such restraint that the colors seem brooding and moody.

BEVERLY PEPPER
Born Brooklyn, New York, 1924; lives Toree Gentile di Todi, Italy

72 **Medieval Axe** 1985

Monotype; edition unique
Image and sheet: 158.8 x 108 cm (62½ x 42½ in.)
Paper: Rives BFK
Printed by Garner Tullis and Richard Tullis at Garner Tullis Workshop.
 Published by Garner Tullis Workshop
Garner Tullis Workshop, California

Like her three-dimensional work, Beverly Pepper's *Medieval Axe* takes for its subject a very basic shape and the weathered, oxidized surface of centuries of exposure to the degenerative forces of nature. Her forms are interpretations in enlarged scale of the most elemental tools that man has forged for himself since pre-history. Their weathered, encrusted surfaces suggest archeological discoveries, objects of inestimable value for their antiquity — a remaining link with earliest man — rather than for conventional aesthetic considerations or preciousness of materials. In *Medieval Axe,* Pepper conveys the objectness of the axe head by isolating the highly textured image on a field of flat, neutral gray, its recessiveness seeming to throw the object into relief. The remarkable feature of the print, however, is the "experienced" texture she is able to transfer from plate to sheet.

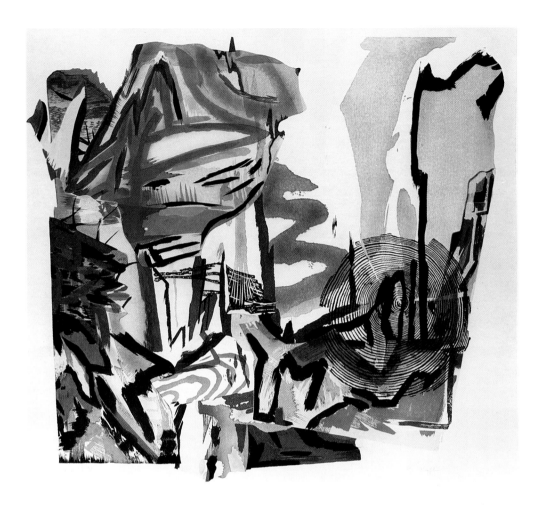

JUDY PFAFF
Born London, England, 1946; lives New York, New York

73 **Yoyogi (State I)** 1985

Woodblock print; edition of 75
Image: 77.5 x 88.8 cm (30½ x 35 in.)
Sheet: 83.2 x 90.7 cm (32¾ x 35¾ in.)
Paper: Echizen Kozo
Printed by Tadashi Toda in Kyoto, Japan, and Hidekatsu Takada in Oakland,
 California. Published by Crown Point Press
*The Brooklyn Museum 85.96, Louis Comfort Tiffany Foundation
 grant purchase*

Named after a park in Tokyo, Judy Pfaff's *Yoyogi (State I)* is an abstract landscape of rock formations and what appears to be a stream running between cliffs. As in her painted constructions, Pfaff creates a personal, highly organized space in this two-dimensional work, mainly through the overlapping of transparent water-based inks accented by a rhythmic, calligraphic pattern of black outlines. The concentric circles in the lower right represent a cross-section of a tree trunk, rolled with a tarry, glossy ink that contrasts with the delicate washes of the other inks, In the second state, the artist did not print the tree stump, substituting spirals of red and black (also printed with oil-based inks), which created another, more frontal plane.

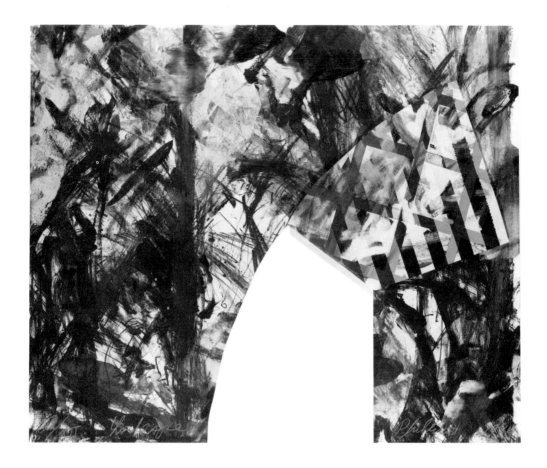

JAY PHILLIPS
Born Albuquerque, New Mexico, 1954; lives New York, New York

74 Landscape IV 1984

Monoprint (lithograph and monotype); edition of 12, each unique
Image and sheet: 75 x 92.7 cm (29½ x 36½ in.)
Paper: Arjormi Arches
Printed by the artist and Lynne D. Allen at Tamarind Institute.
 Published by Tamarind Institute
*The Brooklyn Museum 85.58, Louis Comfort Tiffany Foundation
 grant purchase*

Basing his imagery on highly abstract landscape forms, Jay Phillips usually paints on sheets of metal, cuts a form, bends it back, and paints in a more geometric style on the revealed verso area. The work thus has positive and negative areas, as well as projecting a partially related area in low relief. In *Landscape IV,* one of a series of twelve monoprints, Phillips made a lithograph in brown of a wooded area which he overprinted with a highly gestural monotype to create the image of a glade in afternoon shadow. The folded area is also printed in monotype, a trellislike diamond pattern over stripes, all overlaid with painterly brushstrokes that give the effect of dappled sunlight.

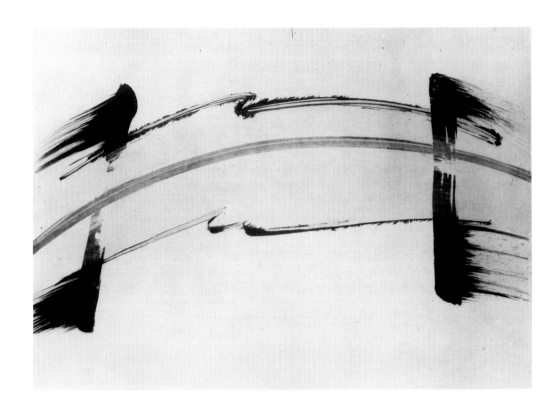

KATHLEEN RABEL
Born Seattle, Washington, 1943; lives Seattle, Washington

75 Fata Morgana (Sky River) 1985

Lift-ground etching, soft-ground etching, aquatint, spit bite, and
 hand-coloring; edition of 10
Image: 42.5 x 58.4 cm (16¾ x 23 in.)
Sheet: 66 x 83.8 cm (26 x 33 in.)
Paper: Van Gelder Zonen
Printed and published by the artist
The artist

The elegant, calligraphic simplicity of Kathleen Rabel's *Fata Morgana (Sky River)* belies the technical complexity of the work. All the intaglio techniques used in the plate, however, never overwhelm the delicacy of the image; they are used to create the necessary illusory textures. Rabel has been exploring fata morganas (mirages seen over water) for several years now in her drawings and prints. The image, its curvilinear treatment suggesting the flow of water, sits in perfect placement on the blank sheet like a mirage in the infinite space of the sky. The print is noteworthy for its economy of line, delicacy of color, and expressiveness of brushstroke.

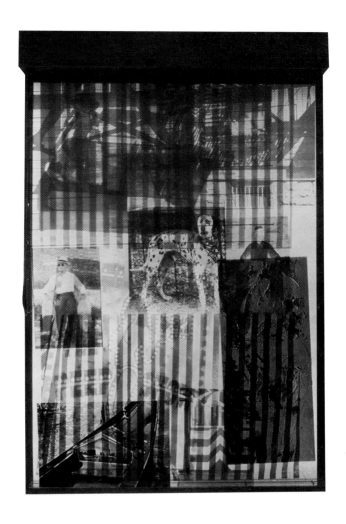

ROBERT RAUSCHENBERG
Born Port Arthur, Texas, 1925; lives Captiva, Florida

76 **Sling-Shots Lit #8** 1984

Wood lightbox assemblage with lithography and screenprinting on mylar and
 sailcloth; edition of 25
Total assemblage: 214.6 x 137.2 x 33 cm (84½ x 54 x 13 in.)
Printed by Alan Holoubek, Chris Sukimoto, and Ron McPherson, assisted by
 Anthony Zepeda, Serge Lozingot, James Reid, Krystine Graziano,
 Rachel Smookler, William Padien, Kevin Kennedy, Mari Andrews, and
 Alan Chung, at Gemini G.E.L. Published by Gemini G.E.L.
Gemini G.E.L., California and New York

The basic premise of *Sling-Shots Lit* is that the viewer is looking through a window, actually
a giant lightbox. At the back is a sheet of sailcloth, printed with a screened and lithographed
photomontage; this sheet is stationary. In front are two layers of clear mylar, likewise printed
with associative photographic imagery; these sheets can be rolled up or down, like window
shades, increasing or decreasing the layering of perception. Rauschenberg thus allows the
viewer to participate, to some degree, in the image-making process, as a change in the position
of either "shade" affects the conjunction of all elements of the image. The viewer is thus
encouraged to analyze how much he/she is able or consciously willing to assimilate from all
the visual data.

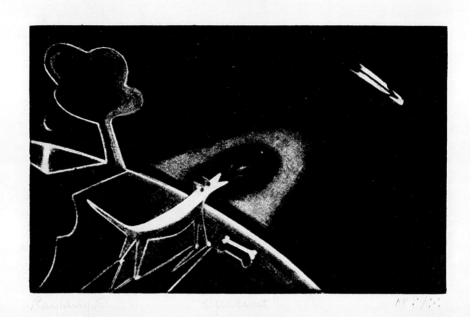

RAYBERRY©
Born Walterboro, South Carolina, 1952; lives New York, New York

77 Life's Comet 1985

Mezzotint; edition of 20
Image: 15.2 x 24.5 cm (6 x 9⅝ in.)
Sheet: 38.1 x 56.5 cm (15 x 22¼ in.)
Paper: Arches Cover
Printed by Mohammed Khalil at MOK. Published by THIS HISTORY
THIS HISTORY, New York

Rather than baying at the moon, the dog in Rayberry's *Life's Comet* stands at the edge of the earth baying at Halley's comet. The arc that represents a section of the globe forms a playful horizon line between earth and the infinite as well as effecting an interesting division of pictorial space. The comet, not the moon, provides the light source, casting elongated shadows of the dog, its bone, and the tree in distinctly outlined black geometric shapes. The moon is reflected only in the water directly beneath it. The dog's bark is depicted as flames, casting a nimbus into deep space. The subleties of Rayberry's burnishing enable him to establish a range of grays into white that is particularly effective in the figure of the dog and in echoing the outline of the tree. The velvety blackness of the mezzotint conveys the impenetrability of the night sky.

ANTHONY RICE
Born Philippines, 1948; lives Sarasota, Florida

78 **Untitled** 1985

Monotype; edition unique
Image: 56.5 x 34.6 cm (22¼ x 13⅝ in.)
Sheet: 76.2 x 56.5 cm (30 x 22¼ in.)
Paper: Arches Cover Stock
Printed and published by the artist
Mary Ryan Gallery, New York

A Southern gothic sensibility pervades Anthony Rice's work with its enigmatic narratives and allusions to voodoo. In the lower right of this untitled monotype is a Medusa figure with its coiffeur of writhing snakes. Within this figure, on a considerably reduced scale, is a childishly drawn skeletal stick figure with exaggerated genitals and relatively realistic breasts, a two-dimensional representation of a wax doll used for occult rites. Two black-bordered triangular forms, one enclosed, the other open, divide the pictorial space in a dramatic way, as does the diagonal spread of the eagle's wings. The opacity of the black areas is intensified by the translucent washes of the hot background colors—red, yellow, and purple.

JAMES ROSENQUIST
Born Grand Forks, North Dakota, 1933; lives Aripeka, Florida

79 **Electrical Nymphs on a Non-Objective Ground** 1984

Lithograph on white laminated plastic; edition of 30
Overall size: 106.7 x 106.7 cm (42 x 42 in.)
Printed by Keith Brintzenhofe, John Lund, Craig Zammiello, and Bill Goldston
 at Universal Limited Art Editions, Inc. Plastic prepared by Frank D'Agostino.
 Published by Universal Limited Art Editions, Inc.
Castelli Graphics, New York
Photo: Eric Pollitzer

To create *Electical Nymphs on a Non-Objective Ground,* James Rosenquist first applied a
stopout to the plate, drew the image, then selectively removed the stopout, leaving a spiked,
interrupted partial image. The image is in three distinct planes. The frontal plane is the di-
agonal from upper left to lower right; this overlaps the mid-plane, the area containing the
open eye. The plane with mouth, nose, and closed eye is overlapped by the two other planes.
The overlaps do not indicate depth, but are a reference to cross-hatching, the linear technique
used in drawing and printmaking to create areas of tone. In *Electrical Nymphs,* Rosenquist
adapts a linear technique to an essentially tonal image, the overlays altering the reading of
the image wherever they connect.

SUSAN ROTHENBERG
Born Buffalo, New York, 1945; lives New York, New York

80 **Missing Corners M** 1984

Monoprint (woodcut); edition of 18, each unique
Image: 31.9 x 18.1 cm (12½ x 7⅛ in.)
Sheet: 55.8 x 38.1 cm (22 x 15 in.)
Paper: Handmade Papei de Amate
Printed by the artist, assisted by Keith Brintzenhofe at Universal Limited
 Art Editions, Inc.
Dolan/Maxwell, Philadelpia

The woodblock for *Missing Corners* is a found plywood remnant, the shape suggesting a Northwest Indian schematic pattern of an eagle. Susan Rothenberg carved into the block a shape that has characteristics of both a human figure and a bone, so that when the block is inked the cut image prints as negative line. She selected a handmade Mexican paper containing flecks of bark, its texture and irregular outline complementing the block. Each impression was inked differently, some in red, some in black. Short, smudgy applications of opaque ink, reminiscent of Impressionist brushstrokes, obscure the grain, while in more lightly inked areas the texture of the wood prints clearly. The inking and placement varied in each impression. Because she inked with her fingertips, the smudges have an inherently autographic quality.

DAVID SANDLIN
Born Belfast, Northern Ireland, 1956; lives New York, New York

81 Living Room with Four Death Daddies of the Copacalypso 1985

Three-dimensional screenprint on plexiglass and wood; edition of 30
Overall size: 53.3 x 22.8 x 35.5 cm (21 x 9 x 14 in.)
Printed by Larry Wright at Larry Wright Art Productions, New York
Co-published by David Sandlin and Larry Wright
Gracie Mansion Gallery, New York

Neither printmaking in three-dimensional format nor the layering of silkscreened sheets of plexiglass to build an image that increases in complexity with the addition of each layer is a previously untried concept, but David Sandlin brings an energy and humor to *Living Room with Four Death Daddies of the Copacalypso* that rejuvenates the concept. Within a house-shaped structure of spray-painted wood, the frontal layers of plexiglass depict a kitschy suburban house as a theater set, highlighting the mundane as the subject of drama. On the most recessed layer of plexiglass is an image combining landscape, lettering, and a cartoon-like head, a backdrop unrelated to the frontal stage set. The mundane and the apocolyptic coexist in uneasy juxtaposition.

ALAN SARET
Born New York, New York, 1944; lives Brooklyn, New York

82 Stars in the Sacred Ground 1983

Portfolio of seven etchings; edition of 25
AS83-103: Hard-ground etching; *AS83-105:* Hard-ground etching;
 AS83-107: Hard-ground etching and relief printing; *AS83-106:* Hard-
 ground etching; *AS83-104:* Hard-ground etching and relief printing;
 AS83-108: Hard-ground etching; *AS83-109:* Hard-ground etching and
 relief printing
Each image: 8.9 x 9.3 cm (3½ x 3¼ in.)
Each sheet: 26.6 x 23.5 cm (10½ x 9¼ in.)
Processed and proofed by Christopher D. Cordes at the University of
 Rhode Island, Kingston, and William Hall at the Printmaking Workshop,
 New York. The editioning was done by Diane Hunt in New York.
 AS83-109 was processed, proofed, and editioned by Diane Hunt.
 Published by MERE IMAGE, Inc.
Two sets: *The Brooklyn Museum 85.41.1-7, Louis Comfort Tiffany
 Foundation grant purchase* (for wall display) and *MERE IMAGE, Inc., New York*
 (for individual viewing)

The image illustrated here is #*AS83-103.*

Alan Saret originally intended these seven small plates as notations to be worked into a
larger image but eventually decided that the small form of discrete images was the ideal
vehicle to convey the relation between his wire sculpture and their mathematical sources.
This portfolio can indeed be seen as a primer to Saret's three-dimensional work, in which the
curving, twisted wires often obscure their theoretical base in mathematical formulae. The
intimacy of scale resembles an artist's sketchbook, a journal of visual ideas; yet the isolation
of each plate on a larger white sheet endows *Stars in a Sacred Ground* with a finish and
elegance not often found in notations on the germination of ideas.

JULIAN SCHNABEL
Born Brooklyn, New York, 1951; lives New York, New York

83 **Mother** 1985

Etching and aquatint on lithographed map; edition of 36
Diptych: two plates, two sheets; each sheet 90.2 x 122 cm (35½ x 48 in.)
Overall size: 180.4 x 122 cm (71 x 48 in.)
Paper: Somerset 300 Gr. Textured Roll
Map lithographed by Mel Hunter at Atelier North Star. Intaglio printed by
 Jeryl Parker at Jeryl Parker. Published by Pace Editions, Inc.
Pace Editions, Inc., New York

Julian Schnabel has placed four irregular black rectangles over two identical lithographed maps, which have been joined top-to-top to create a reversed mirror image with the longitude lines slightly out of alignment. The rectangle at the upper left is narrower than the other three, so that, while the horizontal axis is of a fairly even thickness all the way across, the upper half of the vertical axis is several times wider, giving more pictorial weight to the field of the map. At the right, the white lines drawn over the surface of the map and over two of the rectangles form a stick figure of a woman, as if drawn by a child with chalk on a blackboard. A white circle, like an enlarged, off-center halo, joins all four rectangles and unites all sections of the composition. In the upper left quadrant there is a cross scratched into the black rectangle, with the perpendicular lines of the cross extending to the image edge, and their juncture near the top of the rectangle enclosed by several rudimentary circles. These finely scratched circles join the four small quadrants formed by the cross, echoing the larger halo, while the cross itself reads like a primitive representation of a crucifix lacking the figure of Christ. Schnabel also extends the cartographic metaphor through the various circles, which can be seen as allusions to the globe. Intimations of the universal, mystical, religious, and personal are all conjoined in this deceptively simple image.

SEAN SCULLY

Born Dublin, Ireland, 1945; lives New York, New York

84 **Desire** 1985

Soft-ground etching; edition of 25
Image: 45.1 x 60.4 cm (17¾ x 23¾ in.)
Sheet: 56.5 x 76.2 cm (22¼ x 30 in.)
Paper: Arches
Printed by Mohammed Khalil at M.O.K. Published by the artist
David McKee, Inc., New York

Sean Scully subverts the mathematical precision of his austerely geometrical composition by means of emotionally charged markings within each rectangle of color field. Whereas Barnett Newman used the nervous gestural markings of his "zips" to divide broad areas of color, Scully uses such "zips" throughout the composition, reversing Newman's style by having the zip become the ground, divided by an architecture of geometry. The shaped plate of *Desire* enhances the somewhat architectonic composition of the image. The medium of soft-ground etching, in which the autographic marks of the artist are clearly conveyed from plate to sheet, captures the emotional surface texture that characterizes Scully's work.

RICHARD SERRA
Born San Francisco, California, 1939; lives New York, New York

85 **Paris** 1984

> Hand-applied paintstick on silkscreen and coated paper; edition of 17
> Image: 193.4 x 133.3 cm (76⅛ x 52½ in.)
> Sheet: 216 x 133.2 cm (85 x 52½ in.)
> Paper: Arches Cover
> Printed by Ron McPherson and Rick Weiss at Gemini, G.E.L.
> Published by Gemini, G.E.L.
> *Gemini, G.E.L., California and New York*
> Photo: ©Gemini, G.E.L., Los Angeles, California

In his two-dimensional work, Richard Serra builds up markings to form monolithic masses of shape and texture, redefining the field-ground relationship in a manner comparable to the way his sculptures divide space and force the re-examination of the sites for which they are specifically made. In *Paris,* Serra achieves a texture similar to that of his drawings by applying paintstick over an area that has already been defined by silkscreen. The paper is coated so that the work can be shown without plexiglass, which would obscure the texture and reflect light, making the piece, in effect, a mirror, contrary to the artist's concern with the light-absorbing quality of the black. The title does not refer to either of the two pieces that Serra has recently installed in Paris.

AP 2/9 JS 85

JOEL SHAPIRO
Born New York, New York, 1941; lives New York, New York

86 #1 1985

Wood collage print; edition of 40
Sheet: 31.2 x 21 cm (12¼ x 8¼ in.)
Paper: handmade
Printed by Keith Brintzenhofe at Universal Limited Art Editions, Inc.
 Published by Universal Limited Art Editions, Inc.
Dolan/Maxwell Gallery, Pennsylvania

"Wood collage print" is a term coined by Bill Goldston, Director of U.L.A.E., to describe Joel Shapiro's technique of combining inked wood elements that have not been relief cut but are nevertheless printed like a woodcut. While the technique is straightforward and simple and the scale intimate, the emotional impact of #1 far exceeds the sum of its parts. Besides clearly defining process, Shapiro's economy of means in this print, as in his sculpture, distills the emotional content to a highly compressed statement that operates on multiple levels. While it is tempting to read the image as an abstract human figure in a pose of dejection, the texture of the wood grain and the disjuncture of the compositional elements insistently stress the material and geometry of the image.

ALAN SHIELDS
Born Lost Springs, Kansas, 1944; lives Shelter Island, New York

87 **Polar Route** 1986

Woodcut, screenprint, and relief printing; edition to be determined
Image and sheet: diameter, 119.4 cm (47 in.)
Paper: various TGL handmade papers
Printed by Steve Reeves, Tom Stianese, Rodney Konopaki, and
 Bob Cross at Tyler Graphics, Ltd. Published by Tyler Graphics, Ltd.
Tyler Graphics, Ltd., New York
Photo: ©Steven Sloman

The underlying geometry of *Polar Route,* a circular image from Alan Shield's series in progress *Raggedy Navigation,* is set by eight radial lines that recall spokes of a wheel or the longitudinal lines of a globe emanating as if from one of the poles. Beneath these, however, are four quadrants of dot-patterned areas, two with large and two with small circles, implying another type of charting than conventional navigation maps, an enlargement of commercial tonal printing. Overlaying this are complexes of dye-cut linear patterns that are printed to form tonal areas of color, with white lines creating a central diamond. Perpendicular white lines radiate from the diamond, creating further chartlike divisions. Divisions become progressively less precise as they approach the circumference.

KIKI SMITH
Born Nüremberg, West Germany, 1954; lives New York, New York

88 **Possession is Nine-Tenths of the Law** 1985

Portfolio of nine monoprints (screenprints with monotype); edition of 15
Each image and sheet: 55.9 x 43.2 cm (22 x 17 in.)
Paper: Saunders
Printed by the artist, assisted by Bridgette Engler, at the artist's studio.
 Published by Joe Fawbush Editions
Both sets: *Joe Fawbush Editions, New York*

The image illustrated here is *Lungs.*

By isolating body parts, thereby divorcing them from function, Kiki Smith treats human organs as sculptural forms, urging an analytical formal examination of what is normally thought of only in terms of their utility. Like Rauschenberg, who, in *Booster* (1967), used a five-part X-ray of his body as a wittily ironic self-portrait, Smith treats the inner parts of the body as a subject as worthy of visual depiction as the human face or figure. Her technique in *Possession is Nine-Tenths of the Law* is to define form precisely with line, then to obscure it with semitransparent washes of color. The painterliness of the wash belies the almost anatomical textbook precision of linear elements.

PHILIP SMITH
Born Miami, Florida, 1952; lives New York, New York

89 **Charm** 1985

Monotype; edition unique
Image: 152 x 91.5 cm (59⅞ x 36⅛ in.)
Sheet: 190.5 x 128 cm (75 x 50⅜ in.)
Paper: Stonehenge
Printed by the artist and Anthony Kirk at the artist's studio. Published by
 Art Palace
Art Palace, New York

Density, both physical and symbolic, characterizes Philip Smith's *Charm*. Such divisions as he has created in the overall field are vertical, indicating that the image is intended to be read in columns like calligraphy or, more specifically, hieroglyphics. Smith's imagery has been influenced by recent trips to India and Egypt, where he was especially fascinated by the work of the late Dynastic period. Never directly appropriating, he creates his own mysteries and mythologies, semiotic chartings of a private language. As in his paintings, lines are scratched into the field, creating a primitive quality like drawing into dirt with a stick. From the center of the composition, in the largest independent form, an eye mask simultaneously proposes looking out and looking in. The title refers to an amulet or healing incantation.

JOAN SNYDER
Born Highland Park, New Jersey, 1940; lives New York, New York

90 Things Have Tears and We Know Suffering 1983–84

Woodcut, with hand-coloring; edition of 9
Image: 45.7 x 45.7 cm (18 x 18 in.)
Sheet: 66 x 63.5 cm (26 x 25 in.)
Paper: Yamato
Printed by the artist and Chip Elwell at Chip Elwell. Published by
 Diane Villani Editions
Diane Villani Editions, New York
Photo: ©Steven Sloman

Like the German Expressionists, Joan Snyder turns to woodcut for her graphic expression as the most raw and direct medium, wherein the choice of a particularly rough-grained block of wood can add to the emotional immediacy of the image. In *Things Have Tears and We Know Suffering,* Snyder subverts an image usually consistent with domestic harmony, a baby suckling a mother's breast, into an image of rage and frustration. Snyder overcomes the stasis of the square format, almost as if setting a test for herself, with the almost unbearable emotional intensity of the subject. The hand-coloring is deliberately crude, adding further emphasis to the anger and turmoil of this powerful piece.

STEVE SORMAN
Born Minneapolis, Minnesota, 1948; lives Marine, Minnesota

91 **Blue** 1985

Portfolio of nine prints, incorporating drypoint, monotype, and chine collé;
 edition of 10
Each drypoint plate: 15.2 x 11.5 cm (6 x 4½ in.)
Each monotype plate: 7.6 x 11.5 cm (3 x 4½ in.)
Each sheet: 48.9 x 39.7 cm (19¼ x 15⅝ in.)
Paper: Gampi Silktissue collé on Hatome
Printed and published by the artist
Two sets: *Dolan/Maxwell Gallery, Pennsylvania*

Significantly departing from the complexity that normally characterizes his work, Steve Sorman, in *Blue,* retreats from extravagant collaged veils of gesture and patterning to a restrained examination of line. In the lower plate, he posits a series of positive drypoint lines that vary from shallow scratches to deep and richly burred, contained within a vertical field. Above this, he prints a horizontal darkfield monotype, scratching the lines from the rich blue field to establish a negative linear design. The two plates establish a dialogue about the nature of line. In the example illustrated here, all lines are curved. The drypoint lines are fluid and, except for the uppermost line, enclose vaguely botanical forms. The lines in the monotype plate describe simpler forms and, while suggesting enclosure, never actually meet.

PAT STEIR
Born Newark, New Jersey, 1940; lives New York, New York

92 Self Drawn as Though by Early Matisse 1985

Monotype; edition unique
Image: 22.9 x 22.9 cm (9 x 9 in.)
Sheet: 60.1 x 40.7 cm (24 x 18½ in.)
Paper: Farnsworth
Printed by Hidekatsu Takada at Crown Point Press, Oakland.
 Published by Crown Point Press
Crown Point Press, California and New York

Self Drawn as Though by Early Matisse is one of a series of twenty-three monotypes in which Pat Steir uses the self-portrait as a departure to examine the styles of artists she admires, ranging from Rembrandt through Van Gogh, Picasso, Munch, and Kushner. In this investigation, Steir's concern is with major stylistic shifts throughout art history, using one of the most traditional subjects in post-Renaissance art. Rather than examining herself, her purpose is to dissect and reassemble the work of innovative stylists in order to achieve a better understanding of technique, of how art is actually made. As the title suggests, in this work she is examining Matisse's draftsmanship, the most basic component of the artist's vocabulary.

but they are thinking of you

Through the window you can see
a man going to work
"Inside his house" you think
"there is family".
In smoke rising you see how cold it is

DONALD SULTAN

Born Asheville, North Carolina, 1951; lives New York, New York

(Text by DAVID MAMET, b. Chicago, Illinois, 1947; lives Cabot, Vermont)

93 **Warm and Cold** 1985

Book with nine lithographs (eight of which are hand-colored with watercolor)
 and two photographs: edition of 100
Eighteen sheets, each sheet 53.3 x 43.2 cm (21 x 17 in.)
Paper: Arches 300 Gr.
Printed by Arnold Samet, Tracey Regester, and Judith Solodkin, and hand-
 colored by Cinda Sparling at Solo Press. Co-published by Fawbush Editions
 and Solo Press
Both sets: *Joe Fawbush Editions, New York*
Photo: Ellen Page Wilson

The image illustrated here is *but they are thinking of you.*

To celebrate the birth of their daughters, Donald Sultan and David Mamet decided to collaborate on an artist's book exploring issues of love and affection. The title refers to some of the first sensations experienced by a newborn infant. The two words are so basic that they are used to describe everything from emotional states to styles of painting. Sultan's lithographs do not so much illustrate Mamet's text as create images in harmony with the mood it conveys. Like the words of the title, they have multiple meanings and invite alternative readings. Unlike his two most recent series of *Black Lemons* aquatints, *Warm and Cold* is intimate in scale, less austerely abstract, and more playful in spirit.

WAYNE THIEBAUD
Born Mesa, Arizona, 1920; lives Sacramento, California

94 **Apartment Hill** 1985

Drypoint with chine collé; edition of 35
Image: 63.2 x 48 cm (24⅞ x 18⅞ in.)
Sheet: 79.3 x 60.3 cm (31³⁄₁₆ x 23¾ in.)
Paper: Gampi collé on Arches 88
Printed by Peter Pettengill and Marcia Bartholme at Crown Point Press,
 Oakland. Published by Crown Point Press
Crown Point Press, California and New York

Apartment Hill is a San Francisco street scene in which Wayne Thiebaud arranged actually observed buildings and landscape into a wholly imaginary composition. Eliminating most detail, he built up an almost abstract play of mass and form. The highway that snakes around the base of the hill creates a subtle divison of space that emphasizes the vertical thrust of the hill, although the movement of the traffic creates such a staccato energy that this spatial division has an intensity of visual interest far beyond its compositional function. By isolating the hill from its urban context, Thiebaud endows it with a displaced surreal quality. The creamy color of the Gampi paper creates a soft tone that perfectly complements the expressive richness of the drypoint line.

LARRY THOMAS
Born Memphis, Tennessee, 1943; lives San Francisco, California

95 **Nagheezi Series #3** 1985

Monotype over graphite drawing; edition unique
Image: 40.6 x 77.4 cm (16 x 30½ in.)
Sheet: 56.5 x 92.6 cm (22¼ x 36½ in.)
Paper: German Etching
Printed by Andrew Saftel and John Stemmer at Experimental Workshop.
 Published by Experimental Workshop
Experimental Workshop, California
Photo: Diana Crane

For the last ten years, the central theme of Larry Thomas's prints and his drawings done with charcoal and raw pigment has been an exploration of the mythology and artifacts of Native American cultures. The boat or raft that is the subject of this untitled monotype over drawing is an almost universal symbol of spiritual passage. Like the sculptor Robert Stackhouse, Thomas is involved in a continuing exploration of the bare bones and sinews of this evocative image. Here, he places the boat in an undefined space, heightening the mysterious and mythic qualities of the image. The golden light suffuses the image with an other-wordly luminescence, reinforcing the religious significance of the vessel.

DAVID TRUE
Born Marietta, Ohio, 1942; lives New York, New York

96 **Cold Romance** 1985

Aquatint and spit bite; edition of 10
Two plates *(left):* 121 x 33 cm (47⅝ x 13 in.), *(right):* 121 x 68.6 cm
 (47⅝ x 27 in.)
Sheet: 142.9 x 123.2 cm (56¼ x 48½ in.)
Paper: Somerset
Printed by Brenda Zlamany and Joanne Howard at Jeryl Parker Editions.
 Published by Crown Point Press
Crown Point Press, California and New York

The split image from two separated plates that David True uses in *Cold Romance* proposes a variety of interpretations, no one being more valid than the others. The schematic boat, a recurring True image, invokes visions of passage, both physical and psychological as well as its familiar literary symbolism as a microcosm of society. The left side is positive, a daylight scene, possibly the emergence from a nightmare, while the right side is negative, nocturnal, a passage through the darker regions of the psyche. The division of the plates splits the boat into two passages of geometric abstraction, so that it requires an active connection by the viewer to join the two parts into a recognizable image. The geometric qualities of the boat are reinforced by the painterly, gestural treatment of the ocean.

JAMES TURRELL
Born Los Angeles, California, 1943; lives Flagstaff, Arizona

97 **Deep Sky** 1984

Portfolio of seven aquatints; edition of 45
Each image: 32 x 49 cm (12⅝ x 19¼ in.)
Each sheet: 53.5 x 68.5 cm (21⅛ x 27 in.)
Paper: Rives BFK
Printed by Peter Kneubühler in Zurich, Switzerland. Published by
 Peter Blum Edition
Two sets: *The Brooklyn Museum 85.30.1-7* (for wall display) and
Peter Blum Edition, New York (for individual viewing)

The image illustrated here is *Untitled #5.*

In his installations, James Turrell "paints" with light, projecting what at first seem tangible objects that only on closer examination are revealed as light itself. In the seven aquatints that constitute *Deep Sky,* Turrell deals with the effect of light on interior and exterior spaces. The portfolio consists of projections for his Roden Crater Project, a massive earthwork at a volcano on the edge of the Painted Desert, in which Turrell is creating interior chambers keyed to periodic astronomical events. Aside from the first and the last images that show respectively the exterior of the volcano and the vault of night sky above it, the other five images deal with the manifestations of light within the passages and chambers of the interior. The richness of the aquatint, almost like mezzotint in its velvety blackness, makes the gradation in tones through grays to the white of pure light especially effective.

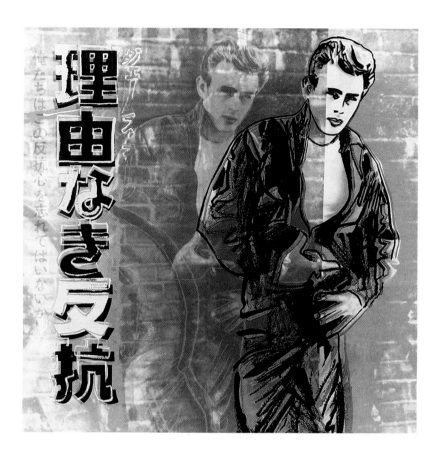

ANDY WARHOL
Born Philadelphia, Pennsylvania, 1930; lives New York, New York

98 **"Rebel Without a Cause" (James Dean)**
(from the portfolio *Ads*) 1985

Screenprint; edition of 190
Image and sheet: 96.5 x 96.5 cm (38 x 38 in.)
Paper: Lenox Museum Board
Printed by Rupert Jasen Smith at Rupert Jasen Smith, New York.
 Published by Ron Feldman Fine Arts, Inc.
Ronald Feldman Gallery, New York
Photo: D. James Dee

"Rebel Without a Cause" (James Dean) is one of ten images taken directly from print advertising to form Andy Warhol's portfolio of screenprints inspired by consumer products and modern icons, *Ads.* All of the images are calculated to produce a shock of recognition, something akin to a knee-jerk response, provoked by either the product or the spokesperson. Again Warhol lays siege to the concept of art as something elevated and set apart from the artifacts of our daily visual environment, which has been the reigning view since the Romantic movement of the early nineteenth century. The selection of James Dean is especially apt, as the alienation he portrayed in the movie *Rebel Without a Cause* encapsulated for 1950s America the figure of the sensitive individual isolated from and unappreciated by society — i.e., the artist. The garish colors and the outline of the figure printed out of register create the effect of a neon sign, the ultimate depersonalization. Warhol has been among the most persistent and iconoclastic in insisting that the overload of visual information in our era has obscured any boundaries between art and commerce.

ROBERT WILSON
Born Waco, Texas, 1941; lives New York, New York

99 **Untitled #5 (from *Parsifal*)** 1985

Lithograph; edition of 35
Image: 58.7 x 89.5 cm (23⅛ x 35¼ in.)
Sheet: 68.6 x 99.1 cm (27 x 39 in.)
Paper: White Chinese
Printed by Karl Imhof at Karl Imhof Druckerei. Published by Fred Jahn
David Nolan, New York
Photo: ©Jon Abbott

This untitled lithograph is one of a set of nineteen that constitutes the scenic breakdown that Robert Wilson has made of a yet-to-be-realized production of Wagner's *Parsifal*. His first step in the development of a production is to make sketches of the effects of scenery and light, which are later worked into fully realized drawings. Like James Turrell, Wilson thus "paints" with light. Since he draws constantly, Wilson had no trouble at all in mastering lithography; it was such a natural step that one wonders why he did not pursue it sooner. In *Untitled #5*, Wilson depicts the lake in *Parsifal*, a very low horizon line separating it from a turbulent sky. Icebergs are at the extreme left, while a gigantic ring of light is partly visible in the extreme right of the sky. The mood is portentous, as befits a tale of the quest for the Holy Grail.

TERRY WINTERS
Born Brooklyn, New York, 1949; lives New York, New York

100 **Primer** 1985

Lithography; edition of 66
Image and sheet: 78.7 x 58.4 cm (31 x 23 in.)
Paper: Whatman
Printed by Keith Brintzenhofe at Universal Limited Art Editions, Inc.
 Published by Universal Limited Art Editions, Inc.
Butler Gallery, Texas

While still dealing with biomorphic forms, Terry Winter's work has become somewhat more reductive, incorporating shapes that have been broken down to basic geometric forms. In *Primer,* the circle serves as a unifying motif among the disparate elements of the composition, sometimes as a component of the forms or else overlaying them. The joined arcs at the bottom of the form on the left are echoed in the form to its right, while the vertical thrust of the two oval components of the second form are complemented in the form above it. When building up mass, Winters emphasizes the linear characteristics of this technique, creating webs of lines rather than flat tonal areas. The emphasis on drawing is also apparent on the field of ruled lines, in which the lines vary subtly in weight and texture.

Glossary of Terms

Note: Where applicable, the cataloque number of prints employing a technique, concept, device, or material that is explained in the glossary are included at the end of the entry.

acid-resist A substance applied to the etching plate that prevents the biting action of acid on the areas covered.

acid-tint A lithographic technique in which the stone is rolled with liquid tusche or an asphaltum mixture and the image is drawn with a brush using an acid solution to remove the grease, thus creating a white image. This achieves a softer line than a scraping technique.

a la poupée (*French* "with a milliner's block") An intaglio technique for printing multiple colors at one time from a single plate by applying each color with a separate folded felt or pad.

aquatint An etching plate treated with a porous ground of rosin, then heated, cooled, and etched, leaving a distribution of tone where the acid has bitten between the grains of rosin. The aquatint process can be used to produce a range of tones. *Cat. nos. 1, 2, 7, 12, 13, 19, 22, 26.1, 26.2, 26.6, 26.7, 26.9, 26.10, 26.13, 26.14, 26.16, 29, 30, 33, 36, 44, 46, 49, 57, 64, 69, 71, 75, 83, 86, 97*

artist's proofs Proofs printed specially for the artist and excluded from the numbering of an edition. They are sometimes numbered differently to distinguish them from the edition. For instance, when the edition is numbered in Arabic numerals, the artist's proofs may be numbered in Roman numerals.

bath In etching, an acid-resistant tray in which the plate is bitten.

bite In intaglio, the action of acid on a plate.

blankets Foam rubber or felt pads used between paper and roller on an etching press. Usually three blankets are used together.

bleed To extend the print image to the edges of the paper.

blind printing The technique of printing uninked plates to produce embossed effects.

bon à tirer (*French,* "good to pull") The proof approved by the artist to establish a standard of printing for the edition. Sometimes called the printer's proof.

burnish Part of the method for correcting incised lines in an intaglio plate (*see:* scraping). After the area below the level of the incision has been scraped away so that it will no longer hold ink, it is smoothed and polished (burnished) so that incidental lines of scraping will not print. *Cat. nos. 1, 7, 12*

burnisher A bent, rounded tool, usually of metal or bone, with a smooth surface for polishing the plate.

burr The ridged metal raised on both sides of the lines that are needle-cut in the drypoint process. In mezzotint, burr is the surface of the plate when worked with a rocker.

chine collé (*French,* "Chinese paste") A process used for adhering paper of a different color or texture onto the overall sheet by dampening and lightly coating the added paper(s) before affixing it to the host paper, usually in the actual printing process. Originally used for adding color to etchings, chine collé is now often used for the varied texture it provides or for the way it absorbs ink. Sometimes transparent paper is collé over areas already printed. *Cat. nos. 28, 40, 61, 91, 94*

chop A printed or stamped symbol used by printers and print workshops (and sometimes by artists and collectors) as a mark of identification The chop may be inked or merely embossed.

collage A print with elements adhered to the surface or incorporated by photographic transfer, stamping, inking, or other methods. *Cat nos. 4, 6, 35, 58, 60, 86*

collograph A print made from an image built up with glue and other materials, such as paper or fabric, on a plate, usually of cardboard or masonite. *Cat. no. 58*

counterproof An impression in reverse taken by passing a print on which the ink is still wet through an etching press with a sheet of paper. Because the resulting image corresponds to the plate, counterproofs are used principally as aids in correcting plates.

crayon manner The use of roulettes and other tools on a plate to create effects like those of a crayon drawing.

deckle edge The untrimmed edge of handmade paper; or this kind of edge imitated in commercial papers.

deep etch A method for printing color in relief and intaglio at the same time.

desensitize In lithography, the use of acidified gum etch to make the undrawn areas insensitive to grease and therefore unprintable.

drypoint An intaglio process in which drawing directly on the ungrounded plate is done with a steel or diamond point. The plate is then inked, wiped, and printed. Drypoint gives a velvety line owing to the burr raised by the cut. This soft line is suitable only to small editions because the burr breaks down with repeated printing. *Cat. nos. 1, 7, 12, 13, 26.2, 26.3, 26.4, 26.7, 26.8, 26.10, 26.12, 26.17, 30, 36, 91, 94*

edition The total prints of a completed single image or series of images that are numbered and signed by the artist and not retained for proofs (*see:* artist's proofs; hors commerce proof; printer's proofs; publisher's proofs; trial proof; working proof).

embossing A process used to create a raised surface, or a raised element printed without ink.

endgrain block A woodblock, usually of boxwood, maple, cherry, or other fruitwood, cut across the grain and used for wood engraving.

engraving The general term for incising lines directly into a metal plate or, in the case of wood engraving, an endgrain block of hard wood. In intaglio, engraving differs from etching in that the plate is not grounded, and it is the pressure of the tool, not the use of an acid bath, that creates the lines in the metal. *Cat. nos. 26.12, 26.15*

etch An intaglio process in which an image is cut through an acid-resistant ground applied to a metal plate. Acid is used to bite this image into the plate. *Cat. nos. 7, 17, 26.1, 26.2, 26.3, 26.5, 26.6, 26.7, 26.9, 26.10, 26.11, 26.13, 26.14, 26.15, 29, 30, 36, 49, 64, 69, 71, 83*

etching ground A thin, acid-resistant coating applied to the face of a metal plate through which a drawing is made with a needle.

etching needle A rounded steel point used to cut through the ground on an etching plate.

foul biting Irregularities bitten into a plate because of imperfect grounding.

ghost impression A second impression taken from a monotype plate. Generally much paler than the original impression,

grain To prepare a lithographic stone by grinding the surface with an abrasive in order to get a desired texture.

ground In general, any surface covering of a plate or stone that the artist removes with various tools or chemical solutions to create an image. In etching and aquatint, an acid-resistant coating applied to the face of a metal plate to protect non-image areas from the action of the acid. In mezzotint, the background produced by the roughening of the plate surface with roulettes and rockers (*see:* rocker; roulette). In manière noire lithography, by extension, the solid black printing image of tusche or asphaltum that the artist works through to create an image that will print white or gray.

hard-ground etching An etching process in which the acid-resistant ground in which the image is cut is hard ground, a compound supplied in a ball shape to be melted on a hot plate. Sometimes hard ground is supplied in liquid form. *Cat. nos. 1, 2, 42.127, 42.128, 42.129, 42.130, 82.AS83-103, 82.AS83-105, 82.AS83-107, 82.AS83-106, 82.AS83-104, 82.AS83-108, 82.AS83-109*

hors commerce proof (*French,* "not offered for sale") A proof of a completed print (aside from the edition) that is not intended for sale and is marked "hors commerce" or "h.c." Such proofs are sometimes retained as archival impressions by the artist or the publisher, or are used as demonstration proofs in marketing the edition.

ink ground An acid resist ground composed of a mixture of two lithographic inks rolled on an etching plate. With a brush and a solvent, such as kerosene or turpentine, the artist paints through the ground, exposing the plate in those areas. The exposed areas are then dusted with rosin and printed in the normal aquatint manner. The advantage of this method is that both brush marks and tone transfer to the sheet. *Cat. no. 44*

intaglio The general term for a print in which the image is either cut or bitten by acid into a metal plate. Ink is forced into this cut or bitten image, the surface of the plate is wiped clean, and a print is made when the plate and paper are run together under pressure through an etching press. *Cat. no. 68*

key block A block or plate carrying the full design with which all other blocks and plates are registered during printing in more than one color.

lift ground A general term for an etching process in which the artist paints directly on an ungrounded plate with a water solution containing either sugar, soap, or salt. Changes can be made by simply wiping the solution off the plate and redrawing. When the final drawing is established, it is dried, then covered with a ground (usually varnish), which is in turn dried. The plate is then immersed in water. The substance used in the water solution lifts off the plate, leaving that area exposed. The plate is then bitten in an acid bath, usually after a dusting of rosin. *Cat. no.75*

linoleum cut A relief print, much like a woodcut, but using battleship linoleum rather than a woodblock. The linoleum is somewhat easier to cut and prints more evenly because it lacks the grain of wood. *Cat. nos. 6, 48, 66*

lithography A printmaking process in which a drawing is made on stone or metal with greasy materials. The surface is prepared so that the image takes ink while the non-image areas repel it. The print is made with a lithographic press. *Cat. nos. 9, 16, 25, 28, 32, 40, 45, 47, 50, 52, 54, 58, 59, 60, 65, 74, 76, 79, 83, 93, 99, 100*

manière noire (*French,* "the black style") In intaglio, another term for mezzotint. In lithography, a technique in which the plate or stone is first covered with a solid black printing image (the ground) using tusche or asphaltum. The image is then scraped, scratched, or picked through the ground, leaving the stone exposed where these marks have been made. Another way to work through the ground (acid-tint) is to paint the image with a brush using a weak acid solution.

mezzotint An intaglio process in which the plate surface is roughened with a tool called a rocker (*see:* rocker), producing a black background. The printmaker then works from black to white in establishing the design, scraping and burnishing the roughened surface to the desired degree of white. In this sense, true white will be unprinted paper. *Cat. nos. 12, 36, 77*

mixed media In printmaking, a non-specific term for the combination of two or more mediums in the production of a print.

monoprint A monotype combined with a partially worked etching, lithograph, screenprint, or relief print. This technique produces a series of prints in which the worked image is constant but the monotype work is different in each impression. *Cat. nos. 5, 17, 18, 35, 58, 74, 80, 88*

monotype A print made from a wet painting on a non-absorbent surface such as glass, plexiglas, or metal that is transferred to paper either by the pressure of the hand or an etching or lithographic press. It is sometimes possible to pull a second or "ghost" impression from a monotype plate, especially if a press is being used. Often the artist will rework areas of the plate between the first and second printings or use more than one plate, but the second impression is never exactly the same as the first. Many types of pigment can be used, including oil paints, acrylics, printer's inks, enamels, watercolors, and gouache, depending on the desired effect. Whatever the pigment, the transfer process entails a metamorphosis between the image as drawn or painted on the plate and the image as it ultimately appears on the paper. *Cat. nos. 5, 8, 11, 14, 15, 17, 18, 20, 27, 28, 34, 35, 38, 39, 42.127, 42.128, 42.129, 42.130, 55, 72, 74, 78, 80, 88, 89, 91, 92, 95*

offset A technique of commercial printing in which the image is taken by the paper from the roller of the press after the transfer to the roller from the plate.

photo intaglio A photomechanical technique for transferring the image to a light-sensitive plate which is then etched normally.

photo lithography A lithographic technique for transferring an image photographically onto a light-sensitive plate. The process is used extensively in offset lithography. *Cat. no. 6*

photogravure An intaglio printing process in which the image has been placed on the plate by photographic means using carbon tissue. *Cat. nos. 12, 36, 61*

planographic printing A term applied to lithography for printing from a flat surface. It is distinct from intaglio or relief printing.

plate mark In intaglio prints, the impression of the plate itself forced upon the paper by pressure of the etching press.

pochoir A process for making multicolor prints and for coloring black-and-white prints using stencils and stencil brush.

press run A single printing on a press. In color prints, there is usually one press run for each color.

printer's proofs Proofs printed specially for the printers who work on an edition. Often marked "Printer's Proof" or "P.P.", these proofs are excluded from the numbering of the edition.

proof An impression taken at any stage in the making of a print that is not part of the edition.

publisher's proofs Proofs specially printed for the publisher(s) of a print and excluded from the numbering of the edition. Usually designated with the name or initials of the publisher.

pull To print; to transfer ink to paper.

rainbow printing The rolling of several colors simultaneously, usually in a continuous blend, onto a stone or plate from a single roller.

registration The correct relationship of succeeding printings to the positioning established by the first-printed image of a design.

registration marks Crosses or other marks used by artists and printers as aids to the accurate positioning of two or more printings on a single sheet of paper. Registration marks are usually positioned to print outside the trimmed sheet area of the final print, or they can be removed before the actual print run is begun. However, some artists consider registration marks part of the process and deliberately make no effort to disguise them.

relief print A print in which the non-image areas have not been cut away and only the surface of the block or plate is inked and printed. Included in this category are woodcuts (the most ancient form of printmaking) and linoleum cuts. *Cat. no. 87*

relief printed etching (or reverse etching) A print from an etched plate in which the surface is inked with a hard roller and any ink that has penetrated the incised lines is wiped away. The opposite of intaglio printing. *Cat. nos. 68, 82.AS83-107, 82.AS83-104, 82.AS83-109*

rocker A mutli-toothed steel tool for laying a mezzotint ground. It is rocked across the plate many times in all directions to produce the characteristic burr.

roulette A tool used to make lines or areas of dots in a metal plate or ground. The roulette has a toothed wheel that revolves, making a track. *Cat. nos. 26.4, 26.8, 36, 71*

salt aquatint A form of lift ground using a saline solution.

sanding The process of working directly on the intaglio plate with fine-grained sandpaper to alter or remove lines or create tonal areas similar to those produced by aquatint.

sandpaper aquatint An aquatint ground obtained by passing a conventionally grounded plate through a press with fine sandpaper placed face down on it. *Cat. no. 26.4*

scraper In intaglio, a wedge-shaped steel tool used for removing burrs and moderating other effects of etching or engraving. In lithography, a leather-covered blade that presses the paper against the inked stone or plate.

scraping In intaglio, a process for making changes in the plate by scraping the metal with a wedge-shaped tool below the level of the incised line so that the scraped area does not hold ink. The surface is then smoothed and polished with a burnisher. In lithography, the process of scraping away tusche or asphaltum with a razor to make corrections or to create an image in *manière noire.*

screenprint A print from a series of stencils, one for each color. Each stencil is applied to a stretched silk or metal mesh so that all areas except those to be printed are blocked out. Originally, the process was called sikscreen printing. During the 1930s, when it was first used as a fine art medium, the designation "serigraph" was coined to distinguish screenprints made by an artist in limited editions from screenprints produced under commercial conditions. Later the term serigraph was further refined to distinquish screenprints in which the artist made and printed his own screens from screenpints produced in collaboration with a printer. Now, when so many prints are the result of artist-printer collaboration, the distinction has become academic. *Cat. nos, 4, 6, 16, 21, 32, 37, 41, 43, 56, 60, 76, 81, 85, 87, 88, 98*

soft-ground etching An etching technique in which the plate is covered with a ground containing wax soft enough to be removed by pressing something into it. This can be anything textured, but paper is most often used. The paper is laid over the waxed plate and pressure is applied with pen, pencil, crayon, or fingers so that the wax is transferred to the back of the paper, exposing an area of the plate that when etched will produce a line with the texture of the paper. The line is softer and grainier than a traditional etched line. *Cat. nos. 2, 7, 24, 42.129, 68, 75, 84*

spit bite A form of aquatint in which the artist paints the acid solution directly on the prepared plate rather than submerging the plate in an acid bath. Variations of tone are easily achieved in this method by the handling of the brush and the amount of acid used. *Cat. nos. 1, 7, 13, 33, 44, 75, 96*

spray-paint aquatint A method of aquatint in which the plate is sprayed with a fine mist of enamel paint from a pressurized can, particularly effective for light and mid-value grays. *Cat. nos. 42.127, 42.129*

state A proof that shows a print in a particular stage of development.

stenciling The general term for the process in which an image is cut from paper or cardboard so that when inked, painted, or otherwise filled in, the image can be repeated throughout an edition. *Cat. no. 66*

stippling A process suitable to engraving, etching, and wood engraving in which the image or areas of the image are made up of small dots or incisions.

sugar lift A form of lift ground in which the artist paints the image on an ungrounded plate with a sugar and water solution which is then dried, varnished, and dried again. When immersed in water, the sugar lifts off the plate, but the varnish around it remains, so that only the image area is uncovered. The plate is then aquatinted by dusting the image with rosin and biting it with acid. *Cat. nos. 29, 33, 42.129*

suite Prints related in theme or image and sometimes in technique. A suite of prints is sometimes published in a portfolio with title page and colophons.

surface-rolled Inked for relief printing.

template A pattern or mold usually made of thin strips of wood or metal. Templates are used both for making monotypes in which the same basic image is to be treated individually in a series and for separating areas of different colored pulp in one sheet of handmade paper. *Cat. nos. 6 and 14*

traced monotype A type of monotype in which ink is either rolled directly on or transferred from a plate to a sheet of paper. Another sheet is placed over the inked paper and the artist draws with a pencil or stylus, picking up ink from the first sheet with lines made in the second sheet. The process bears basic similiarities to soft-ground etching but produces a unique image. *Cat. no. 62*

transfer lithography A technique for transferring to stone or plate a drawing done on grained paper that will take lithographic crayon.

transfer paper In lithography, a paper that allows the image to be transferred from one stone or plate to others.

trial proof An early proof often incorporating the artist's revisions.

tusche Grease in stick or liquid form, principally used for drawing in lithography.

ukiyo-e The style of the classic period of Japanese woodcutting, which lasted from the first half of the seventeenth century to the middle of the nineteenth century. *Ukiyo-e* prints depicted landscapes, images of everyday life, and popular actors, actresses, and courtesans. The woodblocks were cut by master craftsmen after designs by the leading artists of the day. A strict Japanese equivalent to the apprentice and guild system existed, and some cutters cut only landscape, while others cut only figures. First a key block was cut with the major elements in black outline. Areas of mass and pattern were cut in successive blocks. *Cat. nos. 23, 53, 73*

wiping The process of removing ink from the unbitten surface of an intaglio plate, leaving ink only in the lines and areas to be printed. The plate is usually wiped with a ball of muslin or with the hand.

woodblock Originally the piece of wood from which a woodcut or wood engraving was made. A woodblock print now carries the connotation of a woodcut made from a block of fine-grained wood which provides a subtle grain pattern and enables the cutter to create more precise lines. *Cat. nos. 23, 53, 73, 80*

woodcut A relief print cut with a knife, gouges, and chisels from a plank-grained woodblock. *Cat. nos. 3, 10, 31, 35, 51, 52, 60, 63, 67, 70, 80, 87, 90*

wood engraving A relief print cut with a graver, tint tool, or scorper on an endgrain block usually of boxwood, maple, or fruit wood.

wood relief Another term for woodcut. *Cat. no. 5*

working proof A trial proof bearing the artist's or printer's notes and corrections.

Index to Printers

Numbers refer to catalogue entries.

Index to Lenders
Numbers refer to catalogue entries.